DRAW NOW

30 Easy Exercises for Beginners

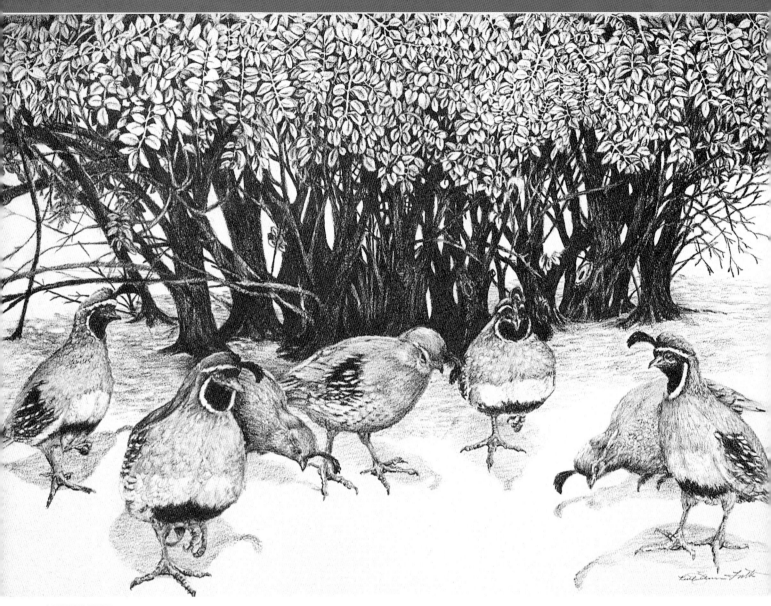

GAMBEL'S QUAIL

Graphite on smooth bristol

11" × 8½" (28cm × 22cm)

DRAW NOW

30 Easy Exercises for Beginners

Ruth Glenn Little

NORTH LIGHT BOOKS
CINCINNATI, OHIO
www.artistsnetwork.com

About the Author

Honored by, among others, the Hawaii Watercolor Society, the Northwest Watercolor Society and the University of Guam Isa Center of the Arts, Ruth Glenn Little is a self-taught artist from northwestern Nebraska. Without the advantage of formal art education, Ruth jumped at the chance at a six-week class with Tom Berger. She found additional inspiration from reading every art book she could get her hands on, including one about Winslow Homer, after which she decided to follow Homer's advice that learning to paint is accomplished by simply painting.

Sharing her art with others has taken Ruth all over the world—to Indonesia, Australia, New Zealand, Guam, Hawaii and the island of Yap in the Federated States of Micronesia. In Yap she was an instructor with the Yap State Department of Education, where she trained illustrators for textbooks written by local educators in the four languages of Yap. These would be the first books for schools to teach students to read and write in their own languages.

To be near her mother, Ruth now lives in Grand Junction, Colorado, where she continues to draw and paint. She teaches drawing and watercolor at Colorado Mountain College and at the Tilman M. Bishop Unified Technical Education Campus of Mesa State College, and she holds several workshops and classes at her home studio. Her work was accepted into the Art for the Parks Traveling Exhibit, and she was a 2004 Art for the Parks Mini 100 finalist.

You can contact Ruth via her website at www.ruthglennlittle.com.

F+W PUBLICATIONS, INC.

Other fine North Light Books are available from your local bookstore, art supply store or direct from the publisher.

11 10 09 08 07 7 6 5 4 3

Library of Congress Cataloging in Publication Data
Little, Ruth Glenn, 1943-
 Draw now : 30 easy exercises for beginners / Ruth Glenn Little.--1st ed.
 p. cm
 Includes index.
 ISBN-13: 978-1-58180-595-6 (pbk. : alk. paper)
 ISBN-10: 1-58180-595-0 (pbk. : alk. paper)
 1. Drawing--Technique. I. Title.

NC730 .L57 2005
741.2--dc22 2004025700

Edited by Mona Michael
Designed by Wendy Dunning
Production art by Kathy Bergstrom
Production coordinated by Mark Griffin

Metric Conversion Chart

To convert	to	multiply by
Inches	Centimeters	2.54
Centimeters	Inches	0.4
Feet	Centimeters	30.5
Centimeters	Feet	0.03
Yards	Meters	0.9
Meters	Yards	1.1
Sq. Inches	Sq. Centimeters	6.45
Sq. Centimeters	Sq. Inches	0.16
Sq. Feet	Sq. Meters	0.09
Sq. Meters	Sq. Feet	10.8
Sq. Yards	Sq. Meters	0.8
Sq. Meters	Sq. Yards	1.2
Pounds	Kilograms	0.45
Kilograms	Pounds	2.2
Ounces	Grams	28.3
Grams	Ounces	0.035

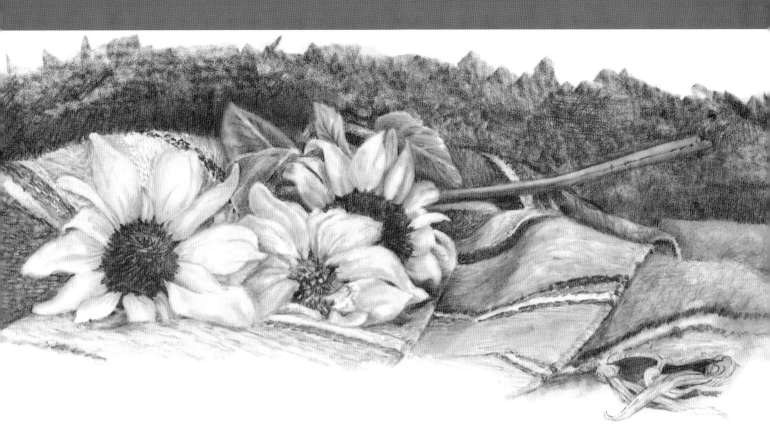

Acknowledgments

I would like to acknowledge Ramji Ragenderan, a six-year-old boy who lived next door to me, for understanding more about me than I did myself. When Ramji asked if I would teach him to draw and paint, I told him I was not a teacher. So he asked if he could just watch. Later, he asked if his friend could watch with him. This led to others asking to watch and eventually evolved into an endless series of classes.

I would also like to acknowledge my student Rae Gorman for planting the seeds for this project. She once asked if I would like to see the book she'd assembled. I was surprised to see that it consisted of my drawing class's weekly handouts with her completed exercises on the adjacent pages.

My thanks to Susan Moyer for her help with this book and for confirming my teaching abilities with her success.

I also want to thank all my students. They have been my best teachers, helping me to define my drawing process and to find the words to explain what I do to express myself.

And most of all I would like to thank my editor, Mona Michael, who so diligently and effectively developed my work in this book.

Dedication

This book is dedicated first to my mother, Crystal Glenn, for always knowing and believing in who I am. A special dedication extends to Tommy Tamangmed and Luke Holoi, special students and artists who will always be in my heart.

TABLE OF CONTENTS

TWO
TECHNIQUES

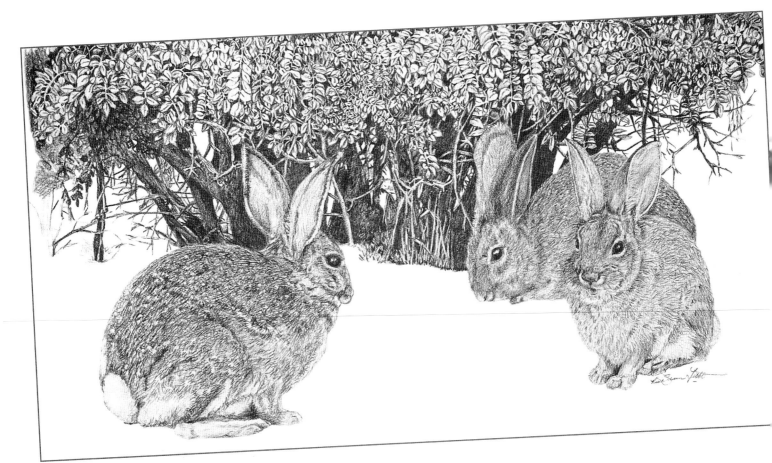

INTRODUCTION

DRAWING IS THE PREREQUISITE FOR EVERY MEDIUM AND GENRE OF ART. Students beginning in watercolor, oil, pastel or acrylics often don't realize the importance of drawing until faced with a blank piece of paper. It is deceiving to watch an experienced artist paint without drawing. Everything in art begins with drawing. This book will introduce to you a series of exercises that, if practiced, will help you discover and master your own drawing talents.

To learn to draw, you need a few things: motivation, discipline, time commitment and pencils and paper. You

do not need to be perfect. Your first drawings will not be masterpieces. But you need to be willing to try, and you need to be willing to make mistakes. Mistakes are often your best teachers. This exercise sequence progresses from holding a pencil and drawing a line to developing a composition for a final rendering. You'll learn observation skills, eye-hand coordination and how to create dimensional line, accurate proportions, value and texture. Most important, you'll learn to draw with confidence. There are no shortcuts, though. You'll benefit most if you master each exercise before moving on. Don't skip exercises or you'll miss information vital to the process and to your drawing.

This book is designed to work in two parts. Part one introduces you to the drawing process, a series of steps you will go through each time you create a new drawing. As you become proficient at basic drawing skills in this process, you'll be ready to move on to Part Two, techniques and exercises that teach you the best way to plan your drawings. You'll learn about composition: the organization of line, space, contrast, value, planes, shapes and texture and how to explore your options using thumbnail sketches.

As you complete the exercises, the mystique surrounding what it takes to become an artist will disappear. You'll refute the old adage that artists are "just born" with their abilities. You'll understand that with motivation, discipline and commitment, you can become an artist. Let's begin!

Follow the drawing process

THE DRAWING PROCESS is a series of steps you'll follow whenever you set out to create a drawing. Each exercise in this book builds upon the last one, presenting a new concept or technique to help you master this process.

Save your drawings!

As you complete the exercises, be sure to save all your drawings. Many times, you'll re-use old drawings in new exercises. Besides, you'll want to look back to see how far you've progressed!

Drawing Supplies

To draw, all you really need is a pencil and paper. A sharpener and an eraser help, too. But an introduction to art supplies and tips for using them opens doors to even more skills and inspiration. The next few pages offer an overview of just a few of the tools available. Be careful though; shopping for art supplies can become addictive!

Graphite

Graphite is the substance commonly known as pencil lead. It's inside the standard pencil and is classified as hard or soft, identified by a letter—H for hard, B for soft—and a number that designates the degree of hardness or softness. For the hard grades, 10H signifies the hardest; the number decreases as the hardness decreases. Softer grades are numbered softest (9B) to down to less soft B and HB the grade between hard and soft. Harder grades produce lighter values and softer grades produce darker values. Application of harder grades produces a more even coverage filling the tooth of the paper but as the grade becomes softer coverage of the paper's tooth is not filled and white areas of the indentations remain. Graphite is shaped for specific uses; below are some common forms.

- *Drawing and sketching pencils* encased in wood are normally made with high-quality graphite that is graded with more accuracy and is smoother than pencils not intended for drawing.

- *Sketching pencils* are rectangular graphite sticks encased in wood. Originally used by carpenters, they provide options for wide strokes.

- *Woodless pencils* are solid sticks encased in a protective lacquer coating that strengthens the stick and keeps your hands free of graphite as you draw. You can sharpen them in a regular pencil sharpener or shape them using a sanding pad. They allow you to use wide strokes and to cover large areas more evenly, smoothly and quickly than wood-encased pencils.

- *Graphite sticks* with no casing are 3" (8cm) to 4" (10cm) long; are square, rectangular or round; are available in soft, medium or hard grades and by the piece or box. Also useful for large areas and bold strokes, you can sharpen them with sanding pads.

- *Water-soluble sketching pencils* are graded as light, medium or dark and are made with graphite that dissolves when you apply water. Use a regular pencil sharpener to sharpen these wood-encased pencils. A sketch made with water-soluble sketching pencils converts easily into a value study using a watercolor brush and clear water to create graded values from the lines of the drawing.

What you need to begin
You can find the basic drawing tools—pencil, paper, sharpener and eraser—almost anywhere.

Rectangular-shaped lead creates loose, broad strokes

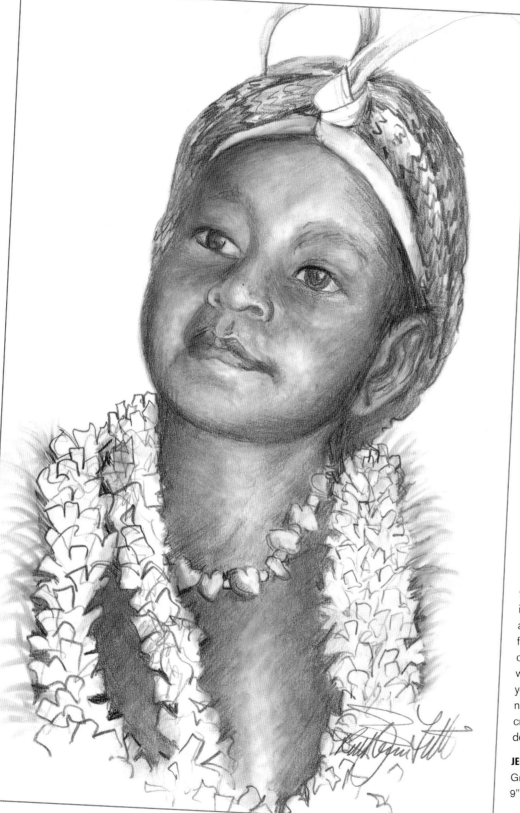

You can create finished drawings with pencils

I created this drawing away from my studio with two mechanical pencils (a 4B and an HB) and a kneaded eraser. Graphite works well for developing light, middle and dark values quickly and easily. A kneaded eraser allows you to soften edges and retrieve highlights.

I created the fern leaves behind the flower lei, called a *nunu* ("decoration" in Yapese), by first applying dark values along the edge, then dragging out feathery leaflike strokes with a soft clutch eraser (see page 14) sharpened with a hand-held sharpener. Developing your skills with graphite and eraser techniques such as these will enable you to create smooth gradual transitions and define detail and texture realistically.

JENNIFER
Graphite on two-ply hot-pressed rag paper
9" × 6" (23cm × 15cm)

Mechanical Pencils

A mechanical pencil is especially practical because the diameter of the tip is consistent and it stays sharp all the time, eliminating the need for a sharpener. A *clutch* holds the lead in the pencil. Mechanical pencils come in two styles: one with a clutch inside and the other, called a lead holder, with a clutch on the outside.

Mechanical pencils with the clutch inside use leads of different diameters—.3mm, .5mm, .7mm, and .9mm—in grades from 6H to 6B. The clutch release is located either at the eraser end or as a button on the side. You insert graphite sticks into the barrel through the opening under the eraser and feed one stick through the tip by "clicking" the clutch. When a graphite stick becomes too short for the clutch to grip, hold the clutch open to remove the small piece. Some mechanical pencils have a refillable eraser at the end of the barrel fitted with a cleaning wire for use if graphite jams in the tip.

It's useful to have on hand several mechanical pencils in different sizes with different grades of graphite. Using pencils of different colors or styles and labeling them according to size and grade makes finding the right pencil at the right time quick and easy.

Lead holders (mechanical pencils with the clutch on the outside) take larger leads—from 1/16" (2mm) to 3/16" (5mm) in diameter—and are available in grades from 6H to 6B. You insert the lead into the tip while holding the clutch open. You can shape the tips to a tapered point using a sharpener made specifically for the lead holder, or you can create wedge or chisel points with a sandpaper pad. After sharpening a lead holder's graphite stick, powdery grains of graphite may flake off and smear on your drawing. To prevent this, use a point cleaner or soft cloth to dust off the tip before continuing to draw.

You'll need a special sharpener to sharpen the larger graphite in the lead holder.

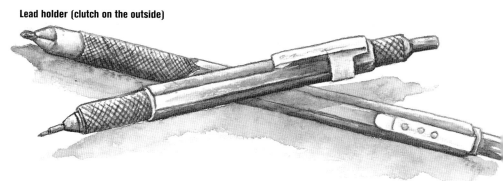

Lead holder (clutch on the outside)

Mechanical pencil (clutch on the inside)

Mechanical pencils provide consistency and convenience

I used mechanical pencils of five different grades to create this drawing. The main advantage of mechanical pencils over other types of pencils is the consistent tip. You don't need to keep a handful of sharpened pencils or to stop to sharpen all the time in order to maintain a working tip. You never end up trying to draw with a short stub, and you don't need pencil extenders. You also get consistent line width. The only disadvantage to mechanical pencils is that you have to become accustomed to feeding the graphite as you draw. Once you get used to this though, it becomes automatic and doesn't interrupt your concentration or progress.

MY SUNFLOWER
Graphite on archival 110-lb. (235gsm) cardstock
8½" × 11" (22cm × 28cm)

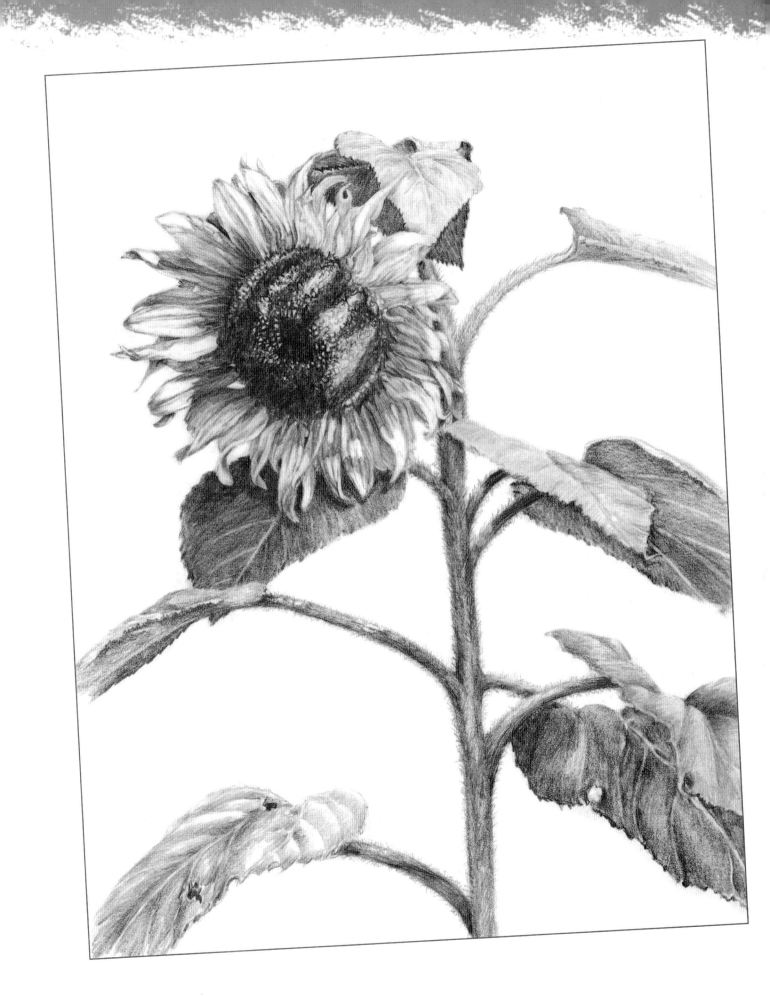

Pencil Sharpeners

The types of pencils you have will determine what sort of sharpener you need. A pencil sharpener may be crank style, handheld, battery operated or electric. Special sharpeners with settings to sharpen points to different degrees are available for pencils of various shapes and diameters. The shavings receptacle size, mount style (wall, freestanding or handheld), the options for inserting a pencil into the sharpener, and the worktable layout are all considerations; when making a purchase, look for ease and efficiency of sharpening.

A knife is useful for sharpening flat points or rectangular sketching pencils, and you can use a sandpaper pad (available at art stores) to refine the tip to create a wedge, blunt or sharp point.

Two types of sharpeners work for flat-point pencils. One uses two receptacles and keeps the graphite in the rectangular shape and the other has one receptacle that changes the rectangular-shaped graphite into a round tip.

Erasers

Erasers are essential to drawing, not only for the purpose of removing mistakes, but also as a drawing tool. Art stores sell special eraser templates to help you make precise erasures. Many different erasers are available and new types appear all the time. These are some good erasers to start with.

- *Kneaded erasers* are made pliable and ready to go by stretching, folding and restretching. You can easily shape a freshly kneaded eraser to pick up media in confined areas, to pick out highlights or to clean smudges. Once your kneaded eraser becomes dirty, clean it by stretching and restretching it to release the medium until the light gray color of the eraser returns.

- *Rubber or plastic erasers* do not scratch, smudge or crumble when larger areas are erased, though the pressure used when the graphite mark was created will influence erasing results. Using excessive pressure with rubber or plastic erasers may compress and change the surface of your paper. Use these erasers only with durable papers.

- *Manual clutch or stick erasers* have a plastic clutch encasement with a refillable eraser stick. Several manufacturers make different styles of clutch erasers that vary in density, softness and diameter. The eraser stick can be removed from the clutch casing and sharpened to a pointed tip with a metal hand sharpener for precise erasures.

Eraser template
A template will help you complete detailed erasures and protect your drawing.

Pencil sharpeners
The type of sharpener you use depends on your drawing tools and your personal preferences. As you experiment with drawing tools, ask your art supplier for sharpener recommendations.

Different erasers serve different needs
Kneaded erasers are useful for recovering light areas; clean rubber or plastic erasers are good for large areas; stick and electric erasers are good for small areas or individual lines.

Blending Supplies

Stumps, tortillions, chamois and old brushes are useful tools for blending, but you can use just about anything as a blending tool. Try household items such as cotton swabs, cotton balls, cloth scraps and tissue. Here are some standard items you should be able to find in any art supply store or department.

- *Stumps* are rolls of compressed soft paper that are pointed like a pencil on both ends, so you can use one end to blend darker values and keep the other end cleaner for blending lighter values. They range in diameter from 1"(3cm) to ⅛"(3mm). Once you've used a stump to blend, you can use the tip as a drawing tool, filling in lighter values with the left-over medium or you can clean and reshape the tip with a sanding pad.

- *Tortillions*, soft paper tightly wound into a pencil-like form, are less durable but also less expensive than stumps. Because they're so inexpensive, you can afford to use a different tortillion to blend each value to keep gradation consistent. Use a black, felt-tip pen to mark each tortillion with the grade or value so you can easily identify it as you work.

- *Chamois,* suedelike leather, used over the finger or the end of a pencil is an efficient blending or cleaning tool. Normally used with charcoal and Conté crayon, it's also good for graphite. It is more efficient than a stump when working in large areas and especially on rough paper when you're trying to achieve smooth value gradation.

- *Used, flat, shorthaired brushes,* especially oil brushes with stiff bristles, make great blending tools. Brush tips hold their shape when blending, whereas both tortillions and stumps lose their tips eventually. Cut and shape brushes, and use them to define texture, soften edges or reduce a heavy application. Use the residue of the medium built up in the bristles to extend your tones.

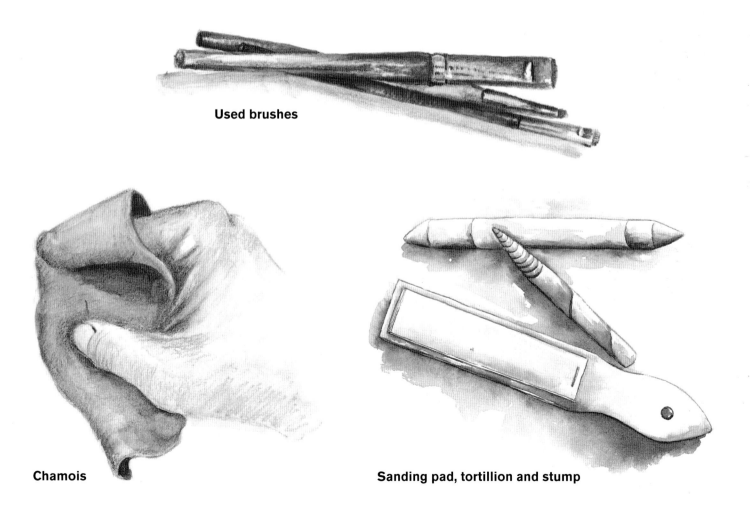

Used brushes

Chamois

Sanding pad, tortillion and stump

Drawing Papers

Drawing papers are made from natural fiber and come in many varieties. They differ in these basic characteristics:

- *tooth* surface texture

- *weight* thickness or density

- *strength* erasability and resilience

- *archival quality or acid-free rating* fiber content and processing for pH-neutral or acid-free quality

Paper *tooth* is categorized as smooth, medium or rough. The drawing papers you choose depend on what drawing tool you're using. Papers with a medium to rough tooth work best for most drawings, though ink or felt-tip pens work best on smooth paper.

Paper *weight* is labeled as light, medium or heavy, or as a specific weight. Drawing papers have 80-lb. (170gsm) to 140-lb. (300gsm) weights. Heavier papers are often classified as two-, three- or four-ply.

Strength refers to a paper's ability to take eraser abuse. It's determined by the fiber used to make the paper and the amount of *sizing* used in making it. Sizing is a gelatinous mixture both added to paper for substance and body and applied to the surface of the paper. It closes the pores of the paper to create a smooth, strong and durable surface that can hold up to erasing and reworking. Strong papers have a sized surface that is durable for erasing and rework. Soft papers have less sizing, with a soft or velvetlike surface.

Newsprint and manila are soft, thin papers that are not able to take eraser abuse. Use newsprint or other soft papers for practice, when you won't need to worry about erasing. You can switch to stronger papers once you begin to create final drawings.

For any drawing that you want to keep, use *archival-quality* paper that's acid free or has a neutral pH. Artwork on this paper remains free of discoloring, spotting or yellowing. Papers such as newsprint or manila, which is made from wood pulp, are not acid free. They are less expensive but turn yellow and become brittle with age. These papers are useful for studies and sketches—anything you're not concerned about keeping.

Become acquainted with different papers as you explore mediums and find what papers work best for you.

Graphite on newsprint or manila

Use pencils with a large diameter when working on this soft, thin paper. While you can't erase or rework very much with these inexpensive papers, you're granted freedom to explore with repeated sketches and studies.

Graphite on medium-weight sketchbook paper

Many drawing pads and sketchbooks have this drawing paper. Graphite penetrates the paper's porous, textured surface, making it difficult to erase.

Graphite on rough charcoal paper

The rough surface of charcoal paper doesn't accept much fine detail, so it is best for sketches and studies. Bold, heavy strokes of adhere well on this surface.

Graphite on smooth paper

Heavy bristol paper comes in smooth or vellum surfaces. While the vellum surface has a bit more tooth, both surfaces are great for blending, erasing and rework. This is my first choice for final renderings.

Sketchbooks

You will find an unlimited variety of choices for sketchbooks. Choose the one with the right paper, size, cover and binding style for you. Spiral-bound books are practical to use open and flat when drawing. Multimedia paper is a wise choice for sketchbook paper and perforated pages will allow you to neatly rip out drawings you'd like to revise or save.

Carry small sketchbooks at all times in your pocket, purse, backpack or car. Draw in them all the time; sketching every day will help you to draw confidently. You'll create valuable journals, and reach everyday benchmarks. These drawings can be inspirations for future drawings and paintings. To preserve your reactions and inspirations, keep notes listing interesting information along with your drawings.

Make *thumbnail sketches*—small 2" × 3" (5cm × 8cm) sketches—to test compositions and explore possibilities quickly. Don't worry about quality in your sketchbook. Focus on quantity, practice and ideas. Sketching may be intimidating as you begin, but it is essential as you develop as an artist.

Clean up excess dust

Pencils and erasers make a lot of dust. That excess will smudge and smear your drawing if you don't sweep it away. Makeup brushes are great for removing excess dust from your drawing, as well as from your drawing tools and erasers.

THE DRAWING PROCESS

The most important ingredient in your drawing success is practice. Like scales for music or stretches before a run, drawing exercises work best if practiced every day. All you really need for this is a pencil and paper; however, you may want some additional items in your toolbox. Look through the list of helpful materials on this page. You can find many of the items in almost any store; you'll find others anywhere that art supplies are sold. Get those pencils ready!

MICHAEL'S DAILY PRACTICE
Graphite on archival 110-lb. (235gsm) cardstock
8½" x 11" (22cm x 28cm)

Helpful materials

5" x 7" (13cm x 18cm) sketchbook

9" x 12" (23cm x 30cm) sketchbook

Primer writing tablet (lined, like the ones used in primary school)

Drawing pad with heavy paper

Three .5mm mechanical pencils

4B, 2B and HB lead for mechanical pencils

6B and HB woodless graphite sticks

White stick clutch eraser

White rubber eraser

Kneaded eraser

Two blending stumps

Soft brush to keep your drawing surface free from pencil dust and eraser residue (makeup brushes work well)

Graphed ruler

Three-ring notebook

Plastic pencil bag for a three-ringed notebook (to protect pencil tips)

A scrap of old denim or heavy fabric (to clean erasers)

How to Use Your Pencil

Using your drawing tool properly involves three main factors: posture, sitting position and how you hold the tool.

Using good posture while drawing will allow you to draw for long periods of time without getting tired or cramped. Good posture will also give you better range of motion with your pencil, so sit up straight! Drawing is supposed to be fun and relaxing, not painful.

There are two sitting positions that work well for drawing. One is to sit directly in front of your work with your arm resting on the table. The other is to sit with your legs parallel to the table with your arm resting by your work. Both these relaxed positions will allow your arm, wrist and fingers to function as a single unit with the freedom to make short strokes or long ones with follow-through. As you begin to work like this, you'll discover you have unlimited flow as you draw. Using only your fingers or wrist to move your pencil stunts your drawing strokes and prevents follow-through. You need a deliberate grip and stable hand and arm to achieve control of your pencil pressure and flow.

Holding your pencil properly will allow you to take full advantage of its potential. Grip your pencil with your thumb and forefinger an inch (3cm) or more above the tip. Allow the pencil to rest on your middle finger. Use a relaxed grip; don't hold on too tightly. This way, you can adjust the angle of the pencil to make different types of lines, and you can adjust the pressure of your strokes to create soft, delicate lines or bold, strong ones.

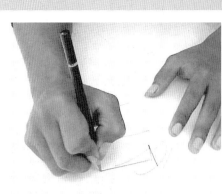

Use the traditional grip for most drawing
The most common method of holding a pencil or pen is to grip it above the tip, between the thumb and first finger, and with the pencil resting on the inside of the middle finger.

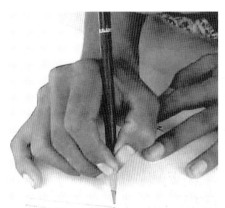

Try this stability trick for details
Hold your little finger stiff against the paper surface to stabilize and guide your hand while drawing details or lines.

Try this for added pressure control
Hold the pencil diagonally through the palm of your hand with your first finger flat against the top of the pencil as a pressure gauge for line intensity and width. Control line character with the shape of your lead's tip (flat, angled or pointed) and pressure variation. This will force you to use your fingers, wrist and arm as a unit.

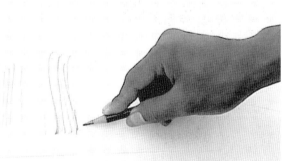

draw now!

1 Using the traditional grip, fill a page with straight lines.

2 Using the traditional grip and the stability trick, fill another page with straight lines. Can you feel the difference?

3 Using the pressure control method, fill another page with lines. Use continuous long lines to practice increasing and decreasing the pressure.

Warm-Ups

Now that you've learned to pay attention to your posture, sitting position and the way you hold your pencil, you're ready to move on with some warm-ups. Doing warm-ups daily will help you focus and practice the correct posture, grip and hand motions, and lead you to consistency of line quality, size, shape, spacing and intensity. Begin each drawing session with these warm-ups.

You can use any paper with lines, though a primer tablet works especially well as a guide for height control and stroke spacing. Strive for graceful strokes that swing in and out as you begin and end. At first, your results might be clumsy and uneven. With practice, your hand will become more relaxed, you'll hold the pencil with a less intense grip and your strokes will become more even.

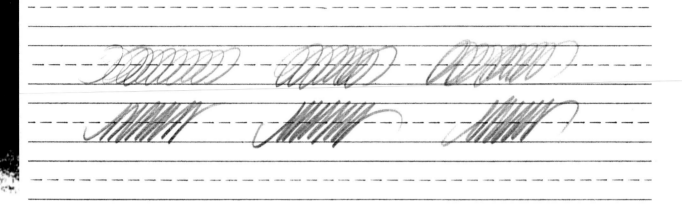

Always begin with simple warm-ups
Draw connected circles and up-and-down strokes slowly and then quickly. Strive for smooth, even shapes and consistent spacing. As you develop more control, create numbers and letters using the connected circles and up and down strokes.

draw now!

1 Draw several lines of connected circles. Maintain consistent spacing, pressure and height.

2 Repeat the process using up-and-down strokes.

3 Draw letters and numbers using connected circles, then use up-and-down strokes.

Create Lines That Show Confidence

Line expresses and communicates a response to an image. The lines of a drawing indicate an artist's security and confidence. As you begin to draw, anxiety may cause scratchy lines. These are often accepted as sketching. However, they indicate insecurity and lack of commitment.

Take control of your drawing anxiety! Place your pencil on the paper and draw with deliberate action. There are no mistakes, only learning opportunities.

Don't do this
Scratchy lines like this one indicate an artist's uncertainty. Create deliberate, strong lines as you draw.

Gain confidence with line
Sit correctly and use your fingers, wrist and arm as a unit to create lines. Make strokes with pressure varied from light to heavy. Draw a line beginning with heavy pressure, then lessen the pressure and quickly lift as you complete the stroke.

Gain confidence with curves
Draw a series of circles with firm strokes. If you find lines of your circles do not flow and you feel uncertain about strokes, do a series of warm-up exercises (page 20) and try again.

Practice true object outlines
Once your lines begin to show more confidence, start looking at objects and drawing exactly the lines you see. This is called drawing a *contour line* or the object's true outline. It takes practice to draw what is actually there and not what you think should be there. Defining what you really see rather than an unexciting line describing what you think you should see will help you overcome a major obstacle to drawing realistically.

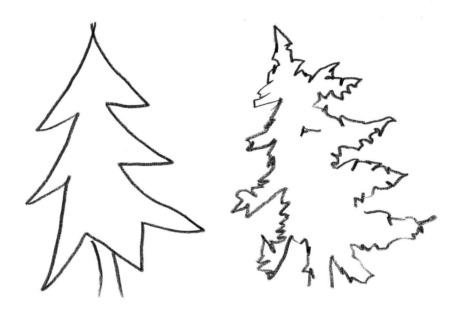

draw now!

1 Draw several lines, beginning with heavy pressure then lessening the pressure and quickly lifting as you complete the stroke.

2 Without lifting your pencil as you draw, create a series of circles. Vary the pressure of your strokes for the circles.

3 Do several contour drawings of objects around you. Make your lines deliberate, not scratchy!

Create Lines That Show Dimension

Once you've begun drawing lines that represent what you see, you're on your way to creating drawings that have dimension. You can add simple, dimensional lines to your contour line to produce the impression of volume.

You can learn to create volume with this very easy exercise using simple lines. Before you begin, gather three pieces of paper. Roll one, fold another into a triangle and fold the third into a square.

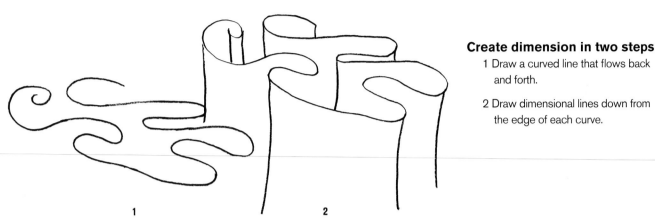

Create dimension in two steps

1 Draw a curved line that flows back and forth.

2 Draw dimensional lines down from the edge of each curve.

Create dimension with simple lines

Arrange the rolled paper, triangle paper and square paper in front of you so that you can clearly see them.

1 Create a line to match the edge of each shape.

2 Draw a line from the top of the shape out about an inch and a half (4cm) and then another to match the angle of the edge of the shape.

3 Connect the matching angle to the original shape with another straight line at the bottom.

4 Inside the shape, connect the edges with straight lines to define the volume of the shaped paper.

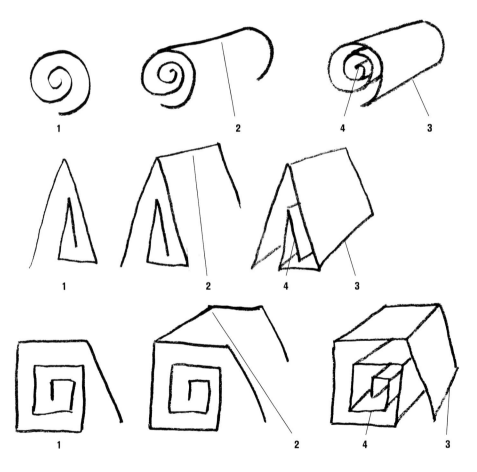

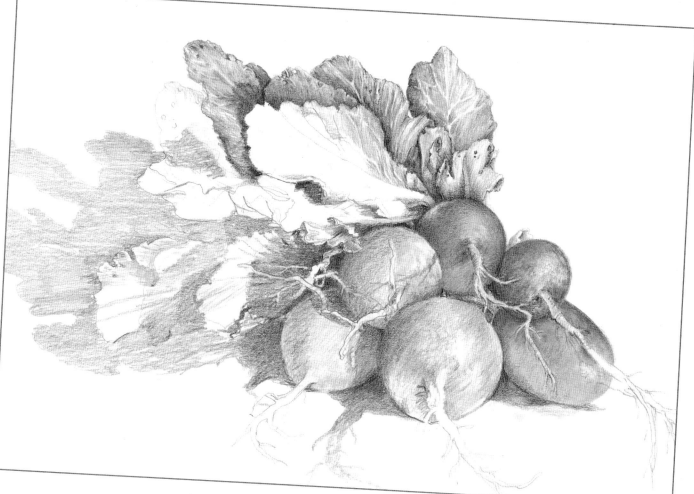

Dimensional lines describe form

I left part of this drawing unfinished so you could get an idea of its progression. If you look closely you can see the original contour line along the cast shadow on the left. The dimensional lines position and separate the leaves and radishes. You can indicate the nature of shapes and their relationships using dimensional lines to describe forms that overlap.

Graphite on lightweight bond paper
8½" × 11" (22cm × 28cm)

draw now!

1 Repeat the CREATE DIMENSION IN TWO STEPS exercise several times until you can do it without thinking.

2 Create dimension using simple lines and your paper props. Mold the paper into more complicated shapes and do the exercise again.

3 Try drawing a rolled-up newspaper, a napkin, a tea towel, an open book or a stack of books as you improve.

Create Blind Contour Drawings

You learned about contour lines in exercise 3 as you practiced true object outlines (called contour lines). This exercise takes you one step further in learning how to draw what you see. When you create a blind contour drawing, you draw while looking only at the subject, not even peeking at your paper. This is the most important building block to your drawing education because it forces you to pay attention to what the subjects of your drawings actually look like, and not what you think they should look like. The purpose of blind contour drawing is to develop observational skills, eye-hand coordination and image memory. Skillful observation is the ability to really see what is there, the details and character of the subject. Eye-hand coordination is the ability to draw or translate onto paper what you see. And image memory is the ability to remember what you see so you can draw it from memory.

Every time you begin a new drawing, you'll first want to get to know your subject by creating at least three blind contour drawings. Begin each new drawing at a different place on the subject so the image remains fresh. Keep your eye and pencil moving at the same rate, defining every change of direction in the contour and indicating placement for shapes inside.

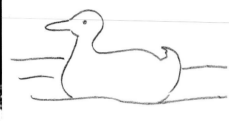

First draw an image from memory
Visualize an image in your mind and draw a simple sketch of the outline or contour from memory without looking at anything except your paper.

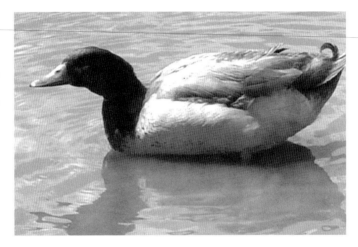

Find an image to draw
Find an actual image or photo similar to the subject you just drew and follow the instructions below to create a blind contour drawing.

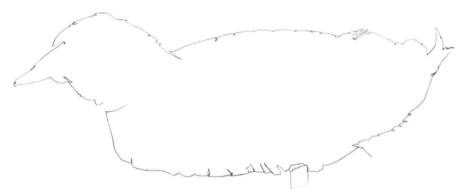

Create a blind contour drawing
Before you begin to draw, feel the edges of the paper while you look at the image. Touch your pencil to the top, bottom and sides of the paper to become familiar with the size you plan to draw.

Focus on the subject. Place the pencil on the paper and draw only the contour of the image. Do not lift the pencil or look at the paper. Keep your eyes and your pencil moving together. Draw as if you were following an ant crawling over the image's profile. Record every projection, crevice, and distinguishing line. Pause at each change of direction to help synchronize your eye and hand motion.

Don't peek!

Remember, look only at the subject, not the drawing. Peeking at the drawing in progress will break your concentration and hinder your image-memory development. Once you look at the drawing in progress, the image of the drawing becomes more dominant in your image memory than the image of the subject. Complete the drawing and then look at the results.

Start each blind contour at a different point

Create at least three blind contour drawings of your subject. Each time you start a new one, begin drawing at a different place on the contour so the image remains fresh and you don't repeat your previous drawing. Add *indicator lines* to give information about the shapes inside the contour and mark where lines inside the contour begin and end, such as the line at the duck's bill.

Develop some inside lines

Once you've done three or more blind contour drawings of a subject's outside lines, turn your attention to the lines inside the subject. It won't be disruptive at this point to look at your paper. Choose a place to begin, place the pencil on your drawing and use the indicators you placed during your blind contour drawings to create lines inside the contour while glancing back and forth between your subject and your paper.

draw now!

1 Complete at least three blind contour drawings of the same image.

2 Using the same image, do a few more blind contour drawings, this time inserting indicator lines in the contour to mark where lines inside the contour begin and end.

3 Choose one of your blind contour drawings to develop a bit more. Begin adding inside lines using the indicators and looking back and forth between your drawing and your subject.

Build Details Into Your Blind Contour Drawings

Once you've completed several blind contour drawings of your subject, you can begin looking at your paper when you draw the same subject again because you will have built some image memory. The blind contour drawing is similar to a jigsaw puzzle border because it helps identify "pieces" to be placed inside. The indicator lines you add to the blind contour drawing provide clues for the details you'll add later. You can continue to define your subject by creating an expressive contour drawing that describes the change from highlight to shadow using lighter stroke pressure to define highlights and gradually increasing pressure to define the change to darker shadows.

Choose your best blind contour drawing for this exercise and follow the instructions to build more details. Begin to identify and draw dimensional lines to establish shapes inside the contour.

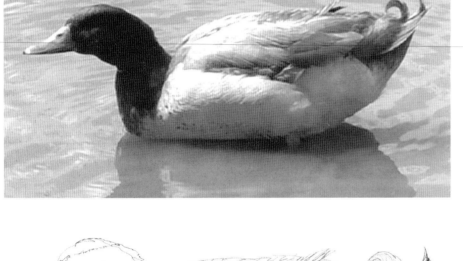

Reference photo or subject
Continue to closely observe your subject as you fill in the details on your blind contour drawing.

Add detail
Look closely at the descriptive lines within your subject's contour. Focus on texture and darks and lights. Draw without thinking about the outcome. Remember, you can look at your paper now. Just be sure you look back at your subject often.

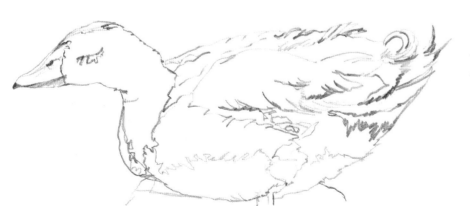

Define the darks and lights
Use light pressure on your pencil to produce a thin, delicate line to suggest highlights. Gradually increase pressure to make heavier, bolder lines to define shadows.

Practice Drawing a Group of Random Objects

Begin with blind contours

Your blind contour drawings should give you familiarity with your subjects and their relationships to each other. Blind contour drawings of groups of objects like this will give you a better idea of their placement on the page and in relationship to each other than if you tried to draw each obect individually.

Begin your second blind contour from a different point

Always start each blind contour drawing from different point on the subject to prevent repeating lines. The second blind contour drawing is almost always less accurate than the first. Once you've seen the first drawing you'll probably want to control the line to make it better, but this almost never works out. Don't be discouraged, though, as this is normal; your next drawings will improve.

Blind contour drawings lead you to details

Your blind contour drawings will surprise you with their accuracy as you begin to add detail and dimensional lines. Ignore any misplaced lines and just draw new ones. You're improving your eye-hand coordination and observation skills.

draw now!

1 Create a series of blind contour drawings, concentrating on the overall outside edge of a group of three or more items from your drawing toolbox, your kitchen or your bathroom.

2 Using the same group of items, create another drawing. This time create an expressive contour identifying light and shadow areas. Use less pressure to define the highlights and gradually increase the pressure for darker values and shadows. Don't forget to include indicator lines.

3 Continue the expressive contour drawing. Use the indicator and expressive lines you created as guides as you place dimensional lines to separate and define the individual shapes of the items in the grouping.

Draw in Perspective: Foreshortening

Objects in the background appear smaller than those in the foreground. This means that the part of your subject that's closest to you will appear larger than the other parts. The sides of a subject pointed toward you will appear shorter than they really are, a phenomenon called *foreshortening*. Your inclination when drawing is to draw those sides out to make them as long as you know they are.

Once you've created several contour drawings you'll begin to understand that the odd shape of your contour drawings includes the foreshortened shapes of your subjects. The indicator and expressive contour lines provide clues for you to establish the foreshortened shape within the contour. Resist the temptation to draw what you think you know about your subject. Instead, draw shapes by comparing size relationships in what you see.

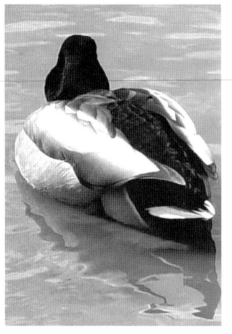

Create blind contours
Find a subject that requires foreshortening and create blind contour drawings. Be sure to use indicator lines in your drawings to mark every irregularity and dimensional line of the contour.

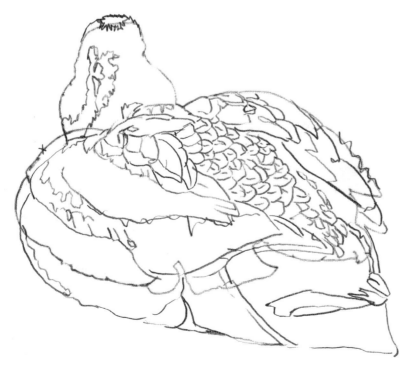

Correct foreshortening on a contour drawing
Choose one of the contour drawings to begin to study and fill in detail dimensional lines. Pay particular attention to the indicator lines you placed in your blind contour drawings. Make adjustments without concern for odd or out-of-place lines. Focus on the lines you see that describe the volume of the foreshortened image. Save this image to reuse for exercise 10.

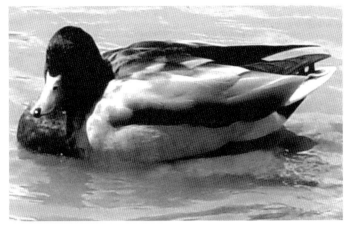

Choose a different angle

Choose another view of the same subject to continue observations and blind contour drawings.

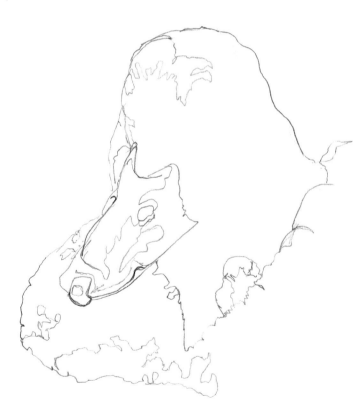

Complete more blind contour drawings

Do two or three blind contour drawings from a different view of the same subject. Look for areas that might require foreshortening. Sometimes only a portion of your subject requires foreshortening. Make separate contour studies of each area. Notice how the flat contour shape of the duck's head and bill are foreshortened in the picture. The bill and head are pointed toward us, so they appear foreshortened. The body is broadside, so it has little foreshortening. Dimensional lines in the drawing will make the volume and depth of the duck apparent.

Make detailed blind contour drawings

Do some blind contour drawings of the areas of your subject that require foreshortening, then choose one drawing to develop. You can look at your paper, but remember to look back to your subject often. Create a detailed contour drawing of the foreshortened areas. Glance between your drawing and subject and define what you actually see. Pay attention to the shapes of light and shadow inside the contour that establish volume as lines define the depth and dimension.

draw now!

1 Create a series of blind contour drawings using an image that requires foreshortening.

2 Choose a blind contour drawing to further develop.

3 Adjust the dimensional lines of the foreshortened areas on your drawing until they are correct.

Draw in Perspective: Ellipses

When you look at a cylindrical shape, such as a can from the side, the circular form at the top does not appear round anymore; it becomes an *ellipse*. An ellipse is a foreshortened circle.

Once you begin looking for ellipses you'll see them everywhere. To draw realistic elliptical objects, keep in mind these two rules:

- Circular or rounded forms with volume are made up of a progressive series of ellipses, each different from the other because of the viewing angle.

- Ellipses are stretched-out circles, and should be symmetrical. They should always be the same shape on both sides if folded in half.

Discover basic shapes

Spheres and cylinders are forms of the same basic shape: the circle. When you connect two circles with straight lines, you have created a cylinder. A circle with volume is a sphere.

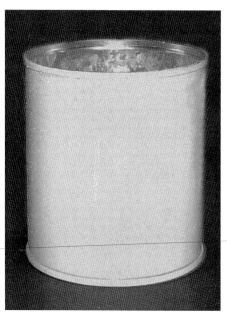

Ellipses widen as the distance from eye level increases

When you look at the can, the ellipse you see at the top is different from the one you see at the bottom. If you were looking at the top of this can from above, it would look like a perfect circle. Viewed from the side, the circle appears stretched and has become an ellipse. The width of the ellipse depends on where the can is relative to your eye level. The farther above the ellipse your eye level is, the wider the ellipse appears and the closer you are to seeing the perfect circle.

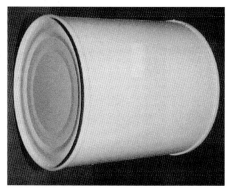

Look for a series of ellipses

Anytime you look at a circular object from any angle other than straight on, the circle becomes an ellipse. A cylinder such as this one is really a series of ellipses.

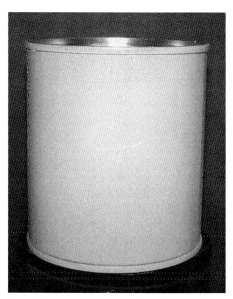

An ellipse at eye level is almost flat

An ellipse appears more stretched out the closer your view comes to eye level.

Draw ellipses

Draw a series of ellipses with several single, fluid strokes in a symmetrical shape. Once you can do this, you'll be able to draw all sorts of images that contain ellipses.

Find ellipses in everyday items
Look around the house for objects made up of
ellipses. Once you've mastered drawing
ellipses with fluid strokes, try your hand at
drawings of objects made up of ellipses.

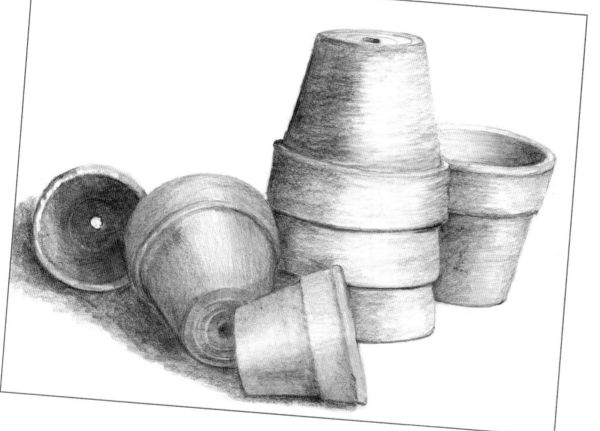

Make sure your ellipses are symmetrical
A grouping of clay flowerpots makes a great subject to study elliptical shapes. I drew a series of
blind contours, exaggerating the indicator lines to show the position of each image, then drew
another expressive contour with indicator lines to identify the light source and use as a guide to
separate the overlapping shapes. I drew a straight line (lightly so that I could erase it easily)
through the middle of each pot to make sure my ellipses were symmetrical.

draw now!

1 Practice drawing ellipses
until you feel sure that they
look symmetrical.

2 Find as many objects containing
ellipses as you can.

3 Concentrating on their ellipses,
practice drawing the elliptical
objects you found.

Discover Negative Space

Space is classified in two ways: positive and negative. You're used to concentrating on the positive or *named* space, or the object you're drawing. Negative space is the the area around that object, the *unnamed* empty space that isn't your subject. Just as creating positive space allows the negative space to appear, defining the negative space allows the positive space to appear.

Sometimes the most effective way to make the correct rendering of a subject is to focus on the shapes of the space around the subject rather than on the subject itself. Define the negative space and allow the subject's shape, or the positive space, to appear.

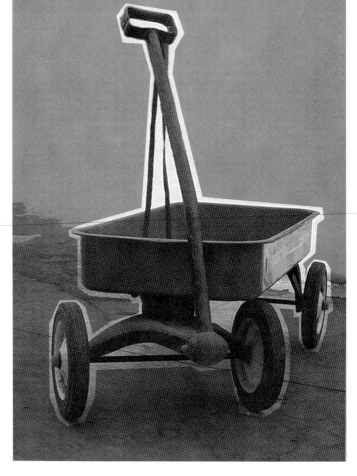

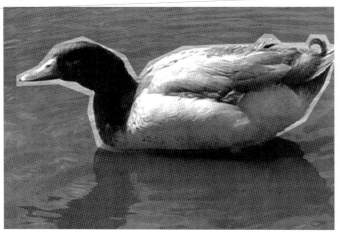

Look for negative spaces in your subjects

Looking for negative space means looking for shapes around the subject. The shaded areas in the pictures can be considered negative space. Notice the V-shape by the duck's neck and the rectangle in the wagon handle.

Adjust your drawing based on studies of negative space

After evaluating the negative space around the duck, I adjusted the lines on my fourth blind contour drawing before beginning to work on a final rendering.

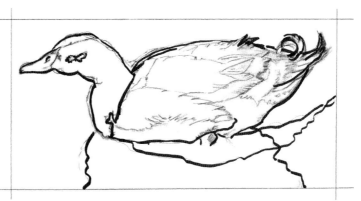

draw now!

1 Use one of the subjects you used for a blind contour drawing. Shade in the negative space you see around the subject.

2 Go back to the contour drawings you did on that subject. Make adjustments based on the negative space you discovered.

3 Find some photographs you'd like to draw. Practice first shading, then drawing, not the main subject, but the negative space around it. As you see negative and positive space notice that one defines the other.

Keep the proportions in your drawings constant

You've completed your contour drawings, but something looks wrong. Chances are, your proportions are off. Here are two simple methods to correct them.

- Using a ⅛" (3mm) graphed ruler, measure the length of your subject, then measure the height. Make sure your drawing has the same ratio of length to height as the subject. The ratio for the duck is three to one (3:1 or 3" (8cm) long to 1" (3cm) high). So if the duck is 6" (15cm) long, the height should be 2" (5cm). If I enlarge the duck to 9" (23cm) in length, the height should be 3" (8cm).

- To measure the image using a pencil, hold the pencil next to a specific portion of the image, marking the distance with your thumb. Then use your pencil to check the size relationships horizontally and vertically. My thumb marks the measurement from the beak to back of the neck in the photo. Compared to the length of the duck, it's one-third of the length of the image.

It's important to keep these size relationships constant. If your subject's height is one-third of its width, your drawing should reflect that. You can also use a proportion wheel, available in the drafting department of art supply stores, to make sure your proportions are constant.

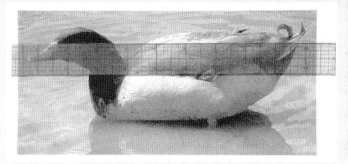

Check proportions with a ruler.

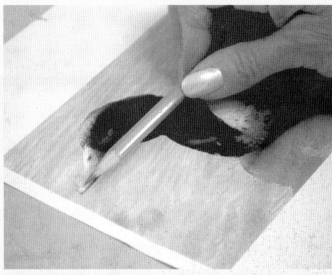

Check proportions with a pencil.

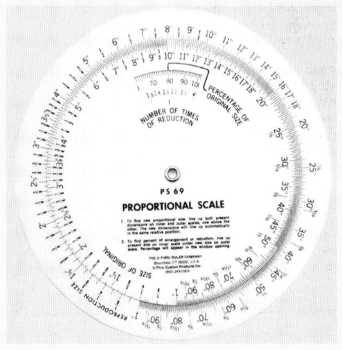

Check proportions with a scale.

Discover Value

Value is the relative lightness or darkness of a shade and is used to establish volume, dimension and even texture in a drawing. The ability to identify value changes and create them in your drawings is one of the most important drawing skills. The use of value in a drawing describes the effects of light and shadow. Light and shadow communicate the volume, dimension, depth and surface texture of an object; therefore value communicates those elements in an image.

A value scale shows the progression from black to white. You can achieve value changes with a single pencil or a combi-nation of tools. Pencils, graphite sticks and charcoal sticks are produced in degrees from hard to soft. Harder grades produce lighter values. They also are less likely to blend or smear, but they will scar and dent paper if you apply too much pressure. Softer grades create darker values with less pressure but do not penetrate the tooth (hills and valleys) of the paper as well as harder grades. Blending the softer-grade strokes fills the paper tooth for smooth transitions. Softer grades smear more easily and are more difficult to erase than hard grades.

VALUE SCALE

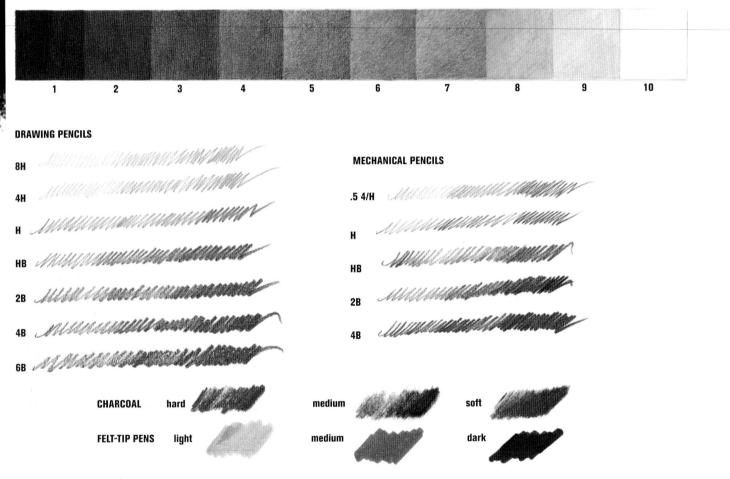

DRAWING PENCILS

8H
4H
H
HB
2B
4B
6B

MECHANICAL PENCILS

.5 4/H
H
HB
2B
4B

CHARCOAL hard medium soft

FELT-TIP PENS light medium dark

Experiment with value

Lots of variables affect the values you'll be able to achieve. The type of medium (pencils or charcoal) you use, the grade (hardness or softness), and the density and pressure of application determine what you'll get. Chart your medium and pencil grades using light, medium and heavy pressure. Keep in mind that different paper surfaces produce different results as well.

White highlights against the dark values of the head describe the shine of the feathers.

Light values contrast with the dark and middle values in the feathers, giving them shape.

4B

2B

B

HB

4H

Soft pencil strokes show textures.

Dark values in the shadows indicate depth.

Value describes your drawing subject

Value contrast develops volume. Without values this image would be only a flat outline. I used a 4H pencil to define the initial shapes, followed by an HB pencil to add preliminary shapes of shadows and to initiate the layers of feathers and texture. The softer grades of 2B and 4B were used to create the darker values. Value contrasts enhance the projecting shapes while preserving the light areas in the drawing. Remember, the shapes in the front of your drawing gain depth when you pay attention to shapes in the back.

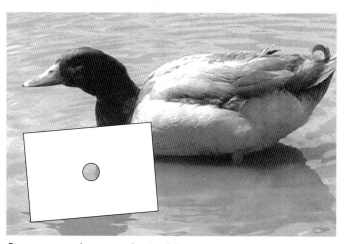

Compare values against white

Values and value changes are easier to see when they're isolated against a white background. Punch a hole in a piece of heavy white paper. Look through the hole at each portion of your drawing subject. The value differences will be much clearer.

draw now!

1 Create a value scale from white to black with eight values in between using pencils.

2 Choose a different drawing tool and create another value scale. It doesn't matter which drawing tool you choose. The goal is to become comfortable with creating value—no matter what the medium.

3 Add detail to an old contour drawing using three to five of the values on one your value scales.

Create Basic Shapes With Volume

There are three basic shapes: circles, squares and triangles. Cylinders, domes, cones, cubes, rectangles and other three-dimensional shapes are forms of the basic shapes. Almost anything that you wish to draw can be broken down into these.

Adding dimensional lines and values in relation to a light source establishes volume. Gradually changing values from light to dark indicates the progression from highlight to shadow and defines volume and dimension.

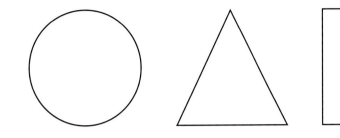

Three basic shapes
The square, circle and triangle are the basis for almost anything you'd wish to draw.

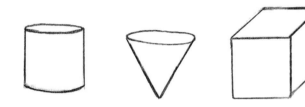

Combinations of basic shapes
Can you find the basic shapes above? The cylinder is two circles or ellipses connected with straight lines. The cube is a combination of squares. What do you see in the cone?

Shading without value
Without value variation, shading provides only mass. Shading of all the same value does nothing to help describe the form.

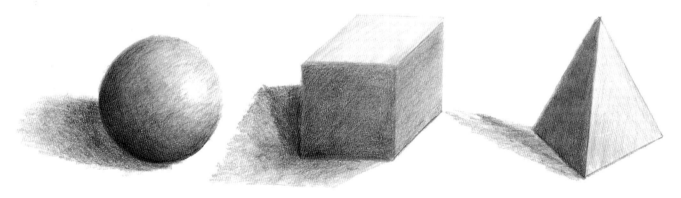

Value changes create volume
A circle, a square and a triangle become a sphere, a cube and a pyramid as light and shadow are used to define volume and dimension. Graded changes in value create volume.

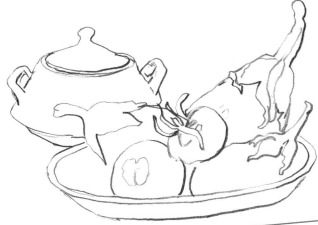

Shapes without volume

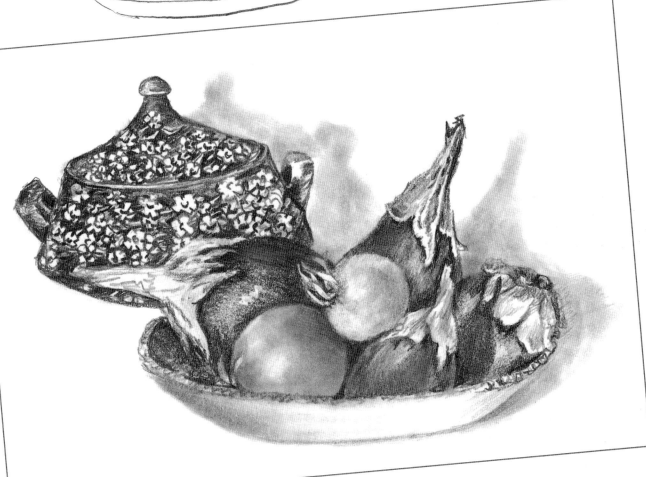

What shapes do you see?

Look for the basic shapes in the bowl of vegetables and the tureen. The tomatoes are spheres. The eggplant is basically a cone, and the tureen is rather like a large cylinder. Recognizing the basic shapes in everyday objects will help you draw them.

draw now!

1 Draw a cube, cone or cylinder by combining basic shapes.

2 Choose three to five values from the value scales you created in exercise 10.

3 Match the values in your value scale to your image to create volume.

Shade With Rhythm

In exercise 10, you began creating value scales and value changes. In exercise 11 you drew basic shapes and began using value to give volume to basic shapes. Remember exercise 2 where you did warm-up strokes, striving for control of smooth, even strokes? Well now you are going to combine these exercises.

First you create a shape. Then you add value gradation using the rhythm of smooth, even strokes. Once you have mastered the rhythmic stroke you will be able to make value changes by either layering strokes or changing the pressure on your pencil.

Begin practicing stroke rhythm using a single pencil; use light pressure to create lighter values and gradually increase the pressure for darker values. Use each of your different grades of pencils—hard to soft—one at a time. When you become satisfied with the smooth transitions from light to dark, begin using a series of pencils to create the value scale.

Warm-up with a one-pencil value strip

Use a single pencil and light to heavy pressure a produce light to dark values. I used a 2B, .5mm mechanical pencil to create these, but any soft pencil will work.

Warm-up with a multiple-pencil value strip

Gather pencils of different grades. Begin with the hardest grade and draw even strokes of the lightest value for the entire length of the strip. This will be your base. Choose a pencil one grade softer than your hardest pencil. Move a little up the strip and fill in the value one level darker for the rest of the length of the strip. Repeat this process, gradually darkening the values using softer pencils to achieve medium and dark values. Do not increase the pressure you place on your pencils, just use softer grades. I began with a 4H and darkened using 2H through HB. I used 4B for the darkest values.

Create Mass Shape and Volume

As you gain skill with rhythmic shading, you'll be able to easily create value changes that show mass shape and volume. I quickly completed these studies using layered strokes and pressure variation.

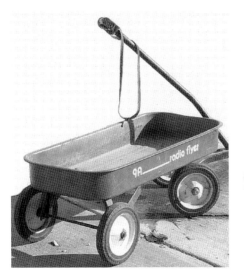

Reference photo

Create a blind contour drawing

Blind contour drawings help you identify shape and space relationships, foreshortening and small details you normally miss when you try to draw what you think you know about subjects. Always begin with the blind contour drawing and force yourself to draw what you actually see.

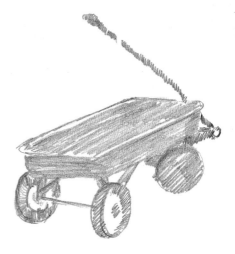

Fill in values with rhythmic strokes

Use the rhythmic value strokes you practiced to fill in the values of your subject. Pay attention to the shadows and light patterns as you draw. Without value gradation, you'll achieve only a solid mass value like this one.

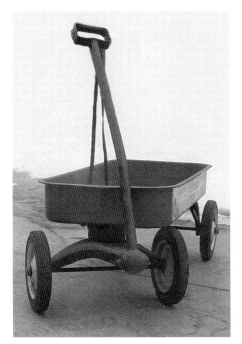

Reference photo

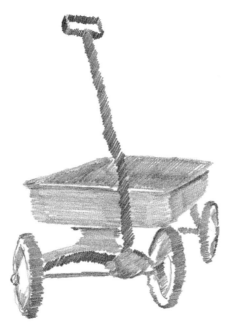

Remember value gradation

As you develop shading rhythm, you'll get a feel for your subject and your strokes will produce smooth gradation naturally. To avoid smearing, work from left to right if you're right-handed; and from right to left if you're left-handed. Define the darker areas and shadows lightly at first, then gradually add the darker values.

draw now!

1 Do the shading with rhythm for warm-up several times until your value gradation comes almost naturally.

2 Complete blind contour drawings until you have two you like.

3 Fill in value gradations on both drawings. For one drawing use only one pencil. For the other use pencils of different grades.

Identify and Use Value

You learned the basics of value by practicing ten-step value scales in exercise 10. As you become more aware of value and better able to capture it with graphite, you'll find there is no limit to what you can draw. You must first train your eyes to recognize values and then train your hand to replicate them with the pencil.

One of the best ways to practice this is with simple value patterns. A three-step value plan—a plan with a light value, a middle value and a dark value—is best to start with. The lightest areas define the highlights, the darkest areas define the shadows, while the middle value develops volume as it bridges the highlight and shadow areas. This limited value scale is so simple, you'll gain confidence as you see the results immediately.

Three-step value plan

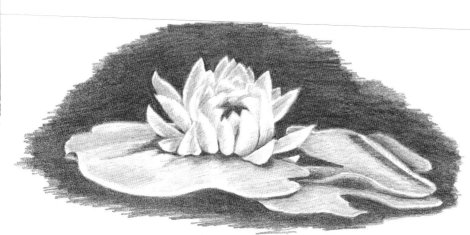

Identify values in the three-step value plan

Identify the light, medium and dark values from the three-step value plan in the water lily. Once you can recognize the different values in an object, you're on your way to creating them in an image.

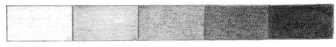

Five-step value plan

.5MM MECHANICAL PENCILS

4B
2B
B
HB
4H

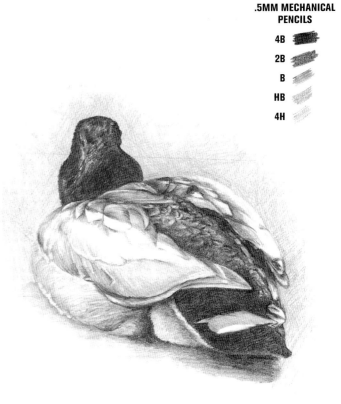

Identify values in the five-step value plan

A five-step value plan provides a wider, more realistic result as values are established. Match the values in the duck to the values in the five-step value plan.

Value plan

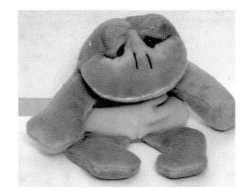

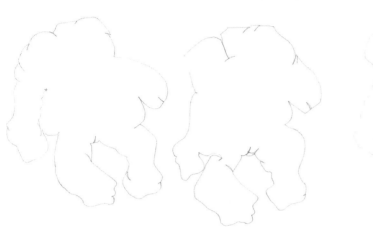

Always begin with blind contour drawings

The first blind contour drawing is often the best. Once you look at your first drawing, you naturally try to control your lines in the next one rather than just drawing what you see.

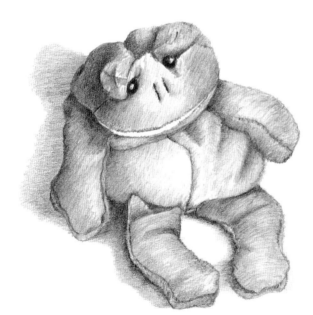

Identify light and shadow with dimensional lines

Once you've chosen a blind contour drawing to work with, add dimensional lines and indicate where you'll place your values for shading and volume. Look back at your subject often. Notice the shadows and highlights. Indicate their placement in your drawing.

Use the three-step value scale to fill in values

Use rhythmic strokes to begin shading the contour of the frog while preserving the highlights. You can use a single pencil to create the value gradation with pressure control and a series of layers. Or you can use pencils of different grades to establish the three values. Use the middle value to define the shadows or darker shapes. As you begin to shade the image, incorporate the contour line into the shading. Lighten your original lines with a kneaded eraser to eliminate the outline effect. Add another layer of middle value to the darkest shadows. Shade gradually to the middle value, then soften gradually to the light value to define highlights. Keep your strokes flowing in the direction that sculpts and follows the basic shape of your subject.

draw now!

1 Make your own three- and five-step value plans based on the plans on page 40.

2 Create two detailed contour drawings of a simple object in your house.

3 Making sure to look at your subject often, fill in the values on one of the contour drawings using only the values in your three-step value plan. Then fill in the values on your second detailed drawing using your five-step value plan.

Blend for Value

You can achieve value gradation by using shading rhythm and by using blending tools. Blending creates a value transition that is embedded into the tooth of the paper, creating a softer and smoother effect. Lifting removes value from your drawing surface, lightening it. The grade of graphite you use determines the blending quality; softer grades blend more easily than harder grades.

Here's a quick review of the tools we covered on page 15:

- *Stumps* come in a variety of sizes to fit in any area. Use one end for darker values and the other for lighter values.

- *Tortillions* are less expensive and more disposable than stumps. Keep several on hand and use a separate one for each value.

- *Brushes* are useful for tight spots, places where you want to accent texture and for when you want to soften con-tour lines. Use flat brushes sideways for narrow blending strokes, or use them flat for wider blending strokes.

- *Chamois* are sometimes just faster than other blending tools. With a small piece wrapped over the tip of your finger, pencil or stick you can get a nice, even layer of value and provide a great base for creating texture.

- *Kneaded erasers* have unlimited use when blending. Use them to remove unwanted lines, lift graphite for lighter values, reclaim your highlights and create textures. Keep your kneaded eraser workable, soft and clean by stretching and folding it often.

As a backup to the blending tools you'll find at most art stores, many household items are handy for blending. Try cotton swabs, tissues, paper towels, old cloth or small pieces of paper.

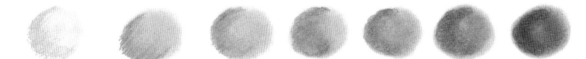

Create a series of circle shapes with different pencil grades and tortillions

Draw a circle and use the same pencil to shade a crescent shape on one side of the circle to represent the shadow. Using a separate tortillion for each value, blend the shading to create a sphere. Grade from the dark shaded value to the lightest value for the highlight. If you lose the highlight, reclaim it with a kneaded eraser.

Protect your work

Work with an old photograph (shiny side down) or a piece of tracing paper under your hand to slide over your work easily and prevent smudging.

Keep different-sized tortillions and stumps in your toolbox

The small details of this shell required a finer point for blending than the large areas like the cast shadow. Keeping on hand many different sizes of tortillions and stumps guarantees you'll have the right size blending tool for all parts of your drawing.

Use blending tools to boost your realistic drawing skills

Adding blending techniques to your arsenal of drawing skills opens the door to realistic drawing. I created much of this drawing with a blending stump.

I used one end of a large stump to blend the dark values at the top of the turnip. I used the clean end to blend the lighter values from the edge of the darks and down the right side. Using only the graphite remaining on the light tip, I added the values along the left edge from the top to the root. For the shadows I used a 4B pencil, then softly blended toward the edges with the stump's dark tip. Then with my kneaded eraser, I softened and lightened edges and cleaned up smudges.

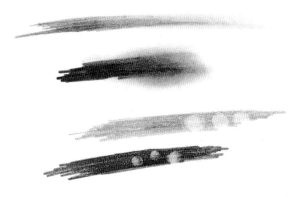

Blend and lift graphite with a kneaded eraser

Create a series of lines in different widths and different pencil grades. Use a small piece of a kneaded eraser to pick up graphite and leave highlight areas in both medium and light strokes.

Can you match these values to the ones you created for either of your value plans from exercise 13?

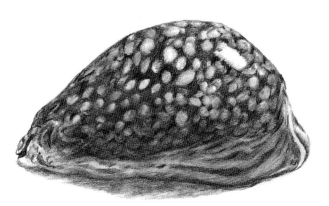

Your kneaded eraser is a multi-use tool

Useful for smoothing out value transitions, your kneaded eraser is key to recapturing highlights like the ones here. Mold your eraser into the right-sized point and dab to lift out lights.

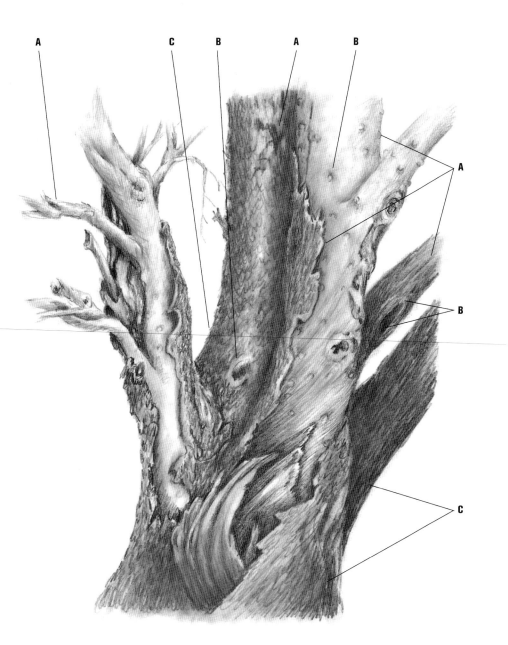

A Use the brush side-
ways to blend.

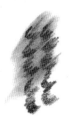

B Use circular motion blending.

C Use flat brush strokes to soften lines.

Match these strokes to the tree

Side strokes blend the tree's shading and
contouring. Wide strokes blend the base val-
ues of the tree with the dark texture of the bark
applied on top. The circular brushstroke natural-
ly forms the protruding knotholes in the tree
trunk. Some of the strokes on the tree have
been identified for you. Can you find any more?

Blend with a brush

A ¼-inch (6mm) brush provides a consistent tip for a controlled blend in
long narrow areas (use flowing strokes). Turned sideways, the brush
produces either a smooth gradation or a textured effect. You can also
modify or soften the edges of strokes with brushes.

draw now!

1 Create a drawing of a cylinder
using a three-step value scale, and
blending the values with a brush.

2 Create a value study of leaves.
Soften edges and create smooth
gradations with a selection of the
household blending tools listed on
page 42.

3 Use a pencil and a cloth or cham-
ois to make a light-value, blended,
even base. Add darker values to
that blended graphite to create a
textured surface such as bricks,
hair or tree bark.

Use Value to Create Texture

Sometimes the main distinguishing feature between objects is their textures. Texture appears as you add value to define light and shadow; it's all about contrasts between lights and darks. As you increase the shadows and highlights, the texture and details of your subject will naturally emerge. Always shade in the basic shape of the image before adding texture detail.

Concentrate on the shadows, shading from dark to light. Then establish the character of the surface texture of each image by looking for the darks. If you lose the highlights in the midst of adding and blending values, you can always recapture them with a kneaded eraser. Focus on your subject to capture subtle differences important to define its form.

Texture distinguishes one shape from another

Many times, basic shapes become different objects mainly because of the texture of their surfaces. The apple and the bear face share the basic shape of the circle; the textures of their surfaces define them. Notice how the value of light and shadow in each drawing creates the illusion of volume; form is maintained as texture is added with more values.

1

2

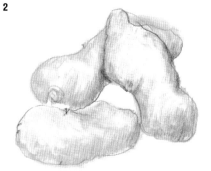

3

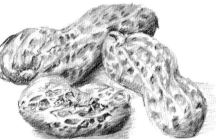

Texture emerges with shadow

1 Draw a blind contour of a simple subject, such as these peanuts.

2 Add darks and lights to the contour shapes.

3 To define the texture, identify the texture pattern and add darker values to areas that indent or recede to project the ridged patterns. Use a sharpened eraser stick or a kneaded eraser to soften the edges of the dark texture and maintain highlights.

Simple techniques create complex drawings

The bee on the flowers was developed the same way as the study of the peanuts. The contrasts of value—light against dark and dark against light—distinguish and project the bee and set it apart from the flowers.

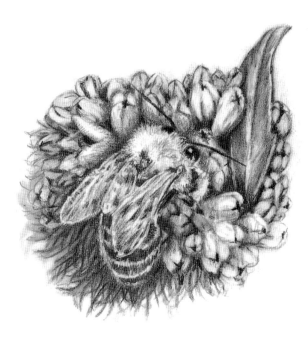

45

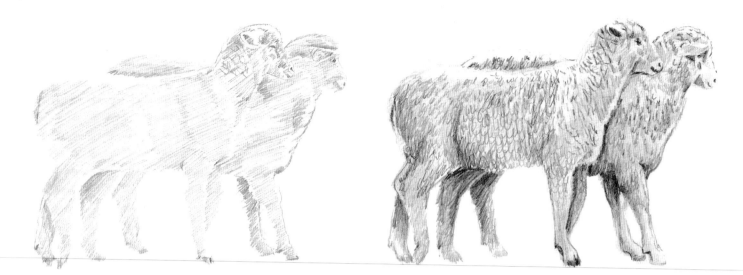

Shade the blind contour drawing

Once you've created your blind contour drawing, shade the mass forms with rhythmic strokes using a lighter pencil, such as a 2H. Concern yourself only with slight variations in value at this point. Go over the shadow areas a little more and leave the highlight areas white.

With darker pencils, develop the basic shapes and values

Position the overlapping shapes, shading what is behind with values that contrast with the lighter projecting shapes. Begin with large areas, such as the rear sheep, then identify and shade in the position of each leg. Once you establish basic receding and projecting areas, begin shading the shadows that define the wool tufts. Define the projecting teardrop shapes by creating shadows behind them. Notice how the value contrasts begin to create dimension.

Your subject's form takes shape with increased contrasts

As you increase the contrasts, the dimensional form of your subject naturally occurs. The final stage of drawing focuses on details such as the individual tufts of wool. Remember not to begin with the details but to gradually work up to them.

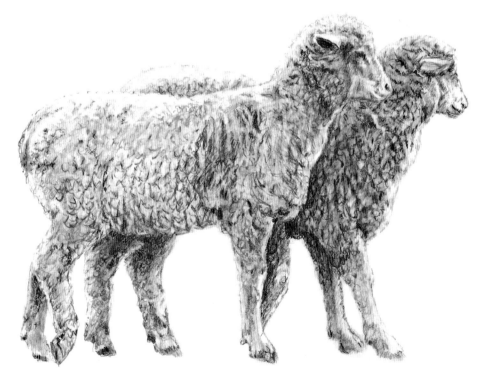

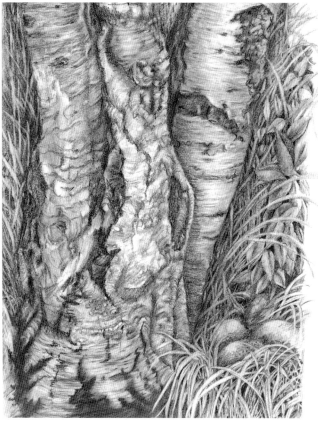

A

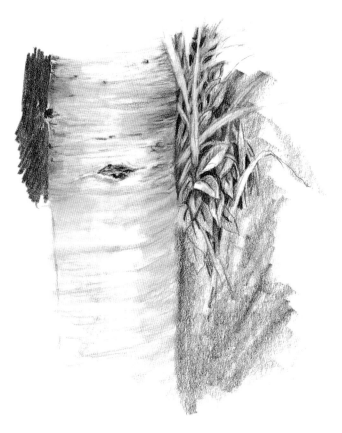

B

Texture differentiates between similar shapes

Texture communicates the nature of a subject. The two trees in the drawings above are differentiated by their bark textures. The bark tells the viewer that drawing A is of an old, scarred and weathered tree and drawing B is of a young tree.

Draw the tree's texture

Armed only with what you've learned in exercises 1 to 15, you can draw a tree like this one.

1 Shade to establish a cylinder form, grading values with smooth pencil strokes and a stump. Lift highlights with a kneaded eraser.

2 Add the scarring texture and darker values with a soft pencil. Use a 6B woodless graphite stick to produce on each side of the trunk the shapes that merge with the original outline of the shape, allowing it to disappear.

3 Use a small, sharpened eraser to lift out grass and leaf shapes. Make the negative space between the leaves and the grass darker with a soft pencil. Working from back to front using a blending stump and a mechanical pencil with 4B graphite, shade each leaf and blade of grass into position.

draw now!

1 Begin with a basic shape, such as a circle or square. Add shading and highlights for texture until that shape becomes an object. How many objects can you create from the same basic shape?

2 Follow the same steps you used to draw the peanuts to draw a tree like the one on this page. Begin with blind contour drawings, add the darks and lights, and complete the texture.

3 Choose subjects with very textured surfaces to practice your observation skills. Capture the basic shape and the lights and darks of the subjects first. Add more lights and darks as the drawing progresses. Look only for the lights and darks on your subject; the texture will come out on its own.

Use Hard and Soft Edges

An edge is where two shapes meet. Artists define edges with value change, not lines. There are three main types of edges: hard, soft and lost. The level of contrast in the value change determines the type of edge.

- **Hard edges** have strong value contrasts and are very defined. The more extreme the value contrast, the harder the edge.

- **Soft edges** have less contrast and tend to fade out. The closer in value the edge is to the area around it, the softer the edge.

- **Lost edges** are known edges that are not visible. These dissolve into adjacent areas of highlight or shadow.

Variation of edges in a drawing produces more drama, interest and excitement. Almost every drawing should have a combination of edge types. A drawing containing a single technique, such as all hard edges, can be monotonous.

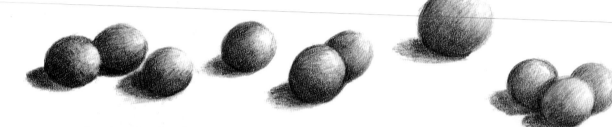

Spheres have hard and soft edges
Even simple spheres like these have varied edges. Value gradation within the spheres creates soft edges that show volume, while overlapping spheres create hard edges.

Begin edges with your contour drawing
Keep edges in mind as you begin to develop a contour drawing. Vary your stroke style—using constant pressure or varying pressure—as you would for drawing an expressive contour. Use darker lines where you have shadows and lighter ones where you anticipate highlights.

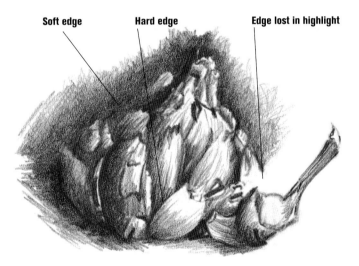

Soft edge Hard edge Edge lost in highlight

Value defines edges within the contour drawing
Follow the guides you set out in your contour drawing to develop the edges with value gradation.

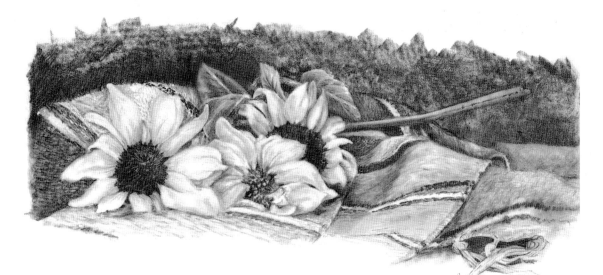

Use dark backgrounds to bring out edges

The dark, abstract background at the top edge of the drawing makes the sunflowers' edges really stand out and improves the visual impact of the overall composition.

Use all types of edges for the best drawings

Look for the hard, soft and lost edges in the highlights and shadows of this drawing. The lost edges in the arms and hair and the hard edges of the strawberry leaves describe the details in this drawing of my cousin's daughter on a sunny day. Variation is key. Use a variety of edges in your drawings to get the best results.

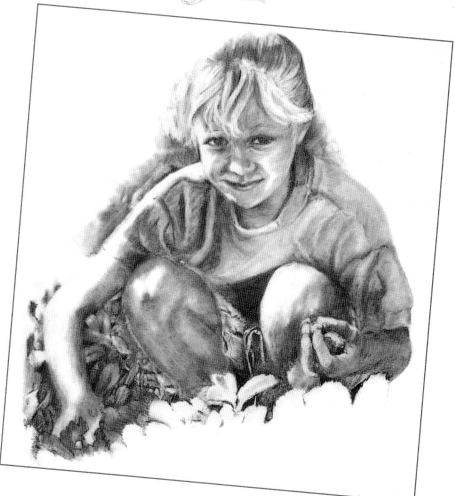

draw now!

1 Create a contour drawing of something in your kitchen, keeping in mind where you will place soft and hard edges. Which edges will you allow to be lost?

2 Develop the drawing's interior, varying the hard and soft edges.

3 Add a blended background to your drawing. Use a kneaded eraser to recapture highlights or produce new ones.

Let's Review the Drawing Process

You've come a long way since exercise 1. Let's stop for a moment to review what you've learned so far.

We all have the desire to begin our drawings with the details (the eyes) before the contour (the shape of the face). Beginning with details rather than general information can create problems with accurate size and proportion though. You must collect facts about your subject first. You must assess its size, shape, physical form and character. Repeated drawings of an image give you benchmarks to analyze, understand and evaluate progress.

Think about the drawing process each time you sit down to draw. Eventually, it will become second nature to you and you'll be able to create realistic drawings quickly.

1 Create at least three blind contour drawings

Blind contour drawings will help you understand the relationships between the simple shapes in your subjects. I began each of these drawings from a different place on the subject to keep a fresh eye as I developed my observations. As in most cases, the second drawing is the least desirable. While the last one needs some adjustments, it is workable. Remember the following as you create your blind contour drawings:

- Define the silhouette to initiate foreshortening.

- Establish relationships among grouped shapes or images.

- Acknowledge the surface texture and create indicator lines for division of shapes and dimension.

- Choose one contour drawing to use as you continue to step 2.

1

2

3

2 Begin details

- Add dimensional lines and identify shapes within the contour (1)
 Add dimensional lines to the best of your blind contour drawings. Look back at your subject often and draw exactly what you see. Do not make adjustments until you've added all the dimensional lines. Lines defining foreshortened shapes may look odd, but they may be more accurate than you think.

- Identify basic shapes and volume forms within the contour (2)
 Find the basic shapes and forms with volume to understand how you will use values to define volume and dimension.

- Identify negative space and shapes (3)
 Negative space is the part of your drawing that isn't your subject, shown here by the darkened areas. As you define negative space, positive space (your drawing subject) will appear.

3 Create a value plan and assign values to develop the drawing

Create a three- or five-step value plan. Using a copy of the selected contour drawing, do a simple value study. Define light and shadow to separate overlapping shapes and indicate volume, dimension and placement of advancing and receding shapes. During this stage you always want to:

- Consciously choose values to use and establish a consistent value pattern of highlights and shadows in your basic shapes.

- Create value gradation from shadow to highlight in your shapes.

- Evaluate the light and and dark values to make sure they match your subject. Are they correct? If not, alter them.

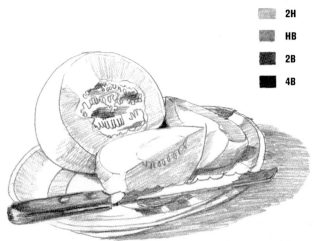

.5MM MECHANICAL PENCIL

▨	2H
▨	HB
▨	2B
▨	4B

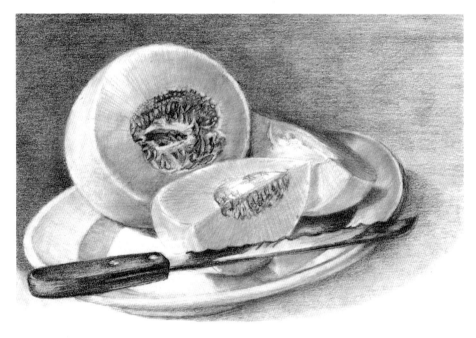

4 Develop the surface character and edges

After you've taken a drawing through the phases of the drawing process, you're ready for the final rendering. Use the value, shape and dimension information you gathered to describe your subject.

- Use light and shadow to define and bring out the texture of each shape in your drawing and to further enhance the volume and dimension.

- Use value contrast to create, for interest and balance, a variety of hard, soft and lost edges.

draw now!

1 Choose a familiar subject—something you see almost every day. Repeat exercises 5 and 6 with it.

2 Using the same subject, repeat exercises 7 and 9.

3 Using the same subject, repeat exercises 10, 12, 13 and 16. You should have several drawings of the same subject at this point. You're really getting to know your subject with these exercises. Once you've finished going through the review, compare the last drawing with your first blind contours. Chances are, your drawings have improved dramatically.

TWO
TECHNIQUES

Once you've made the steps of the drawing process an automatic part of your drawing ritual, you'll be able to compose drawings quickly and without hesitation or anxiety. Confident drawings come from extensive study and practice, whether you want to draw for your own enjoyment or to fulfill a career goal. Following a daily routine of drawing warm-ups and exercises will turn you into an artist. You'll naturally draw while looking at your subject rather than at your paper. Your contour lines will automatically lead to dimensional lines and values.

Concentrate at first on drawing the people, animals and objects in your everyday life. You'll feel more confident and secure when you draw subjects for which you have a passion and understanding. Existing image memory and emotional ties come together while working with familiar subjects, resulting in self-assured drawings.

Now it's time to explore specific techniques you can use to create drawings in the way that best expresses what you are all about.

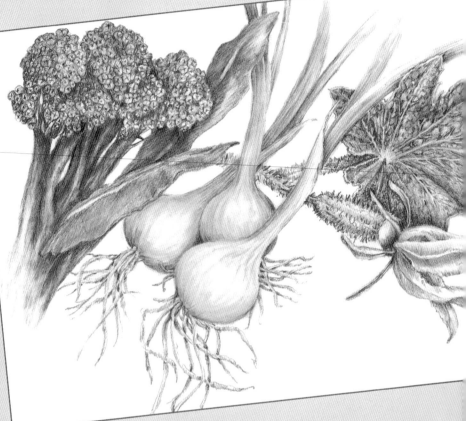

Familiar subjects become art with the drawing process
Using the exercises discussed so far, you can produce an interesting drawing from something as ordinary as this group of vegetables. Grading value from the darkest shadows to the lightest highlight defines the basic shapes of the subject and the volume and dimension of each vegetable. Blending tools smooth and even out the gradation. Shading what is behind each image pushes forward what is in front. Notice the positions of the onions and how their tops are shaded in progression. The darkening of the shape behind each image pushes forward the shape in front. Broccoli flowerets, the onions and the leaves are set into position by the shading of what is behind them.

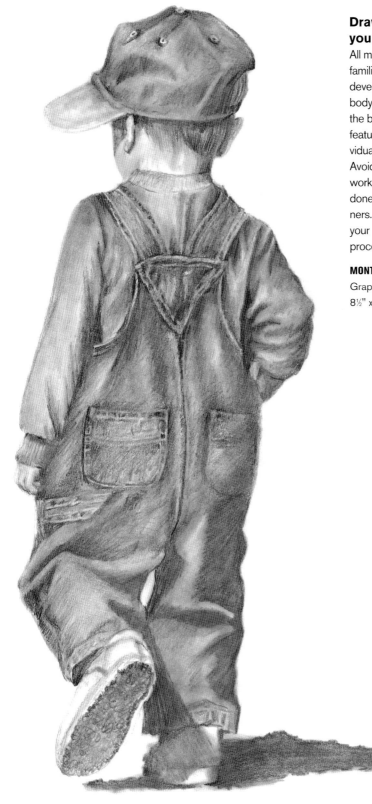

Draw profiles and back-views of your friends and family members

All my students want to draw members of their families. When you first begin drawing people, develop overall shapes to identify gesture, body structure and the way clothing hangs on the body. Look for and focus on distinguishing features, other than facial, that identify an individual and work to create that in your drawing. Avoid drawing the front view of a face. Portrait work is a skill all its own. It's exciting if well done, but can be very disheartening for beginners. You'll experience success if you choose your subjects wisely and follow the drawing process with each subject.

MONTANE
Graphite on smooth bristol
8½" x 11" (22cm x 28cm)

Create Gesture Drawings

Gesture drawings are quick drawings that express the feeling of movement. They are not meant to be detailed works of art, but are often purely suggestive and incomplete. In fact, if you spend more than a few minutes on a drawing, it is no longer a gesture drawing. As you practice gesture drawings, you develop image memory, which is the basis for future drawing success.

How to Approach Gesture Drawing

The goal with gesture drawing is to simplify lines to identify basic gestures to capture the essence of an image. Quick contour lines enhanced with expressive values depicting light and shadow simplify and dramatize a subject.

You can practice gesture drawings using either actual subjects or photographs of them. Using a felt-tip pen works well for gesture drawings and helps deter the natural inclination to stop and try to erase an out-of-place line. Instead you must ignore the misplaced line and make the correct line around or on top of it.

Keep your lines simple. Observe your subject. Determine the light source and indicate values with stroke pressure. Use heavy pressure and dark values for deep shadows and light pressure for light areas and highlights.

Quick gesture drawings allow you to capture moving subjects

Watching from inside the car, I drew unnoticed as I waited for a friend. I quickly sketched a group of men from a vineyard discussing the crop. I didn't erase at all, as that would have broken my momentum and wasted time. I simply redrew lines to capture their gestures and movement.

Sometimes you need a photo

Whether it's a chance moment like this gesture drawing from a photo of my granddaughter or a planned necessity like the drawing of the hummingbird, capturing a moment on film sometimes provides a perfectly natural gesture.

Carry your sketchbook and pencils with you always and try to capture those special moments. But don't underestimate the value of your photos; they can provide a wealth of material.

Try ink for gesture drawings

Using ink to create gesture drawings prevents erasing and forces you to focus on detail observation. You can quickly establish patterns of shadow and highlight and focus on how line communicates overall body structure. With this kind of drawing you avoid defining details of facial structure. You focus on line and movement.

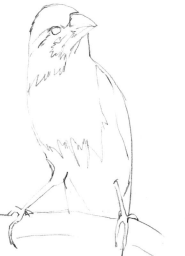

Gesture drawing captures an action or communication

This drawing captures the bird's curiosity. Since birds rarely sit still, it's helpful to build a collection of photos as you begin to draw them. Make a reference sketchbook comprising studies and drawings of birds and other subjects from nature. These sketches will build up your image memory and drawing skill, enabling you to sketch faster and more successfully from life.

Capture key details

This drawing identifies foreshortening, patterns of light and shadow, and dimensional lines necessary for a final rendering.

Create several gesture drawings of the same subject

One sketch cannot express your response to a subject or provide you with the information you need to create a final rendering. I first worked out the composition of the final rendering of Emily (page 49) with several gesture drawings like this one.

draw now!

1 Find a familiar object to use as a drawing subject. Use simple lines to identify the basic gesture that produces the essence of the image. Create several drawings based on this object and spend no more than two minutes on each drawing. Use a timer if you need to.

2 Go through a family photo album. Create a series of gesture drawings from photographs of subjects in action. Spend no more than two minutes on each drawing.

3 Get someone to model for you, changing poses every five minutes. Create a gesture drawing for each pose.

Draw From Life

Once you've created gesture drawings from live models you're well on your way to drawing from life. When you draw subjects from life, you capture a single moment, much like a camera would in one frame. Your experience creating gesture drawings should help you do this exercise, in which you'll take your gesture drawing a step further. These drawings should still be completed quickly, but you can spend longer than five minutes on each one if you like.

Begin looking for simple subjects. Make gesture drawings of details of separate components of a subject. Draw just one leaf instead of the whole plant. Repeat drawings several times to identify lines that strengthen the communication. Analyze each drawing, and make necessary changes before beginning another one. Practice with people, animals and nature to become familiar with your personal approach and the outcome.

Study your subject

I began both of these drawings with blind contours and indicated the placement of the leaves and flowers with short indicator lines to separate and develop the forms. Once I captured the contours on paper, I began more complex drawings using the indicators as clues to develop and separate each part of the subject, then to define shapes with dimensional lines.

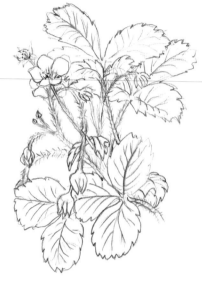
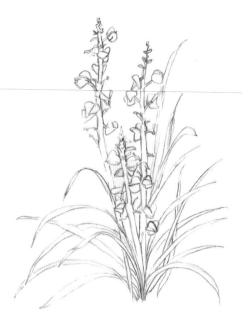

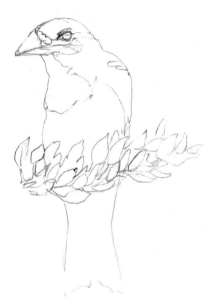
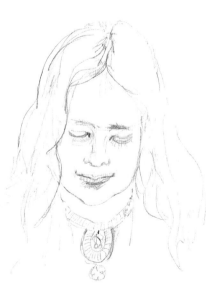

Don't forget details when drawing from life

While gesture drawing doesn't leave much time for the details, giving yourself a bit more time to draw from life allows you to capture important characteristics that catch your eye, such as the bird's branch and the fancy edge of the girl's T-shirt.

draw now!

1 Create several two-minute gesture drawings of a simple subject from life, such as a plant or flower.

2 Choose a gesture drawing to further develop. You may restate or even erase lines.

3 Repeat steps 1 and 2 with one person or more as your subject.

Save time with tracing paper and a light table

Worried that you'll mess up your best gesture or contour drawing as you add detail? Tracing paper provides a way to redraw or refine a sketch without starting over. Using tracing paper to trace a drawing from a sketchbook or to rework a drawing in progress allows you to keep the original drawing intact while you explore additions or changes before creating a final rendering. Once you complete a drawing, you can use tracing paper to move it to a clean surface without eraser marks. Here's how to transfer your drawing.

1 Place a sheet of tracing paper over the drawing you want to preserve or change. Use a black felt-tip pen to trace it. The felt-tip pen on the tracing paper will make it easier to see your drawing through the paper in step 2.

2 Attach a clean sheet of drawing paper over the tracing paper from step 1. Place the attached papers on a light table or other clear or white surface. Lines from the felt-tip pen should show through easily.

3 Use a .3mm mechanical pencil with 2H or HB lead and light pressure to trace the drawing. Too much pressure will damage the drawing paper by making a depression mark that cannot be removed or camouflaged.

Make Your Own Light Table

A light table is a stable translucent surface with a light below. Art supply outlets have many styles of light tables and lightboxes, but you can make your own using a glass tabletop with a light underneath. Be mindful of the temperature and leave plenty of distance between the light and the glass, especially if the light bulb is halogen.

1 Screw four stationary doorstops to the top of an old table or a piece of plywood. Place a sheet of plastic (such as white Plexiglas), frosted glass or clear glass ¼" (6mm) thick on top of the doorstops.

2 Place under-the-cabinet fluorescent lights between the glass and the table in the space created by the doorstops. Always cover clear-glass light tables with a sheet of tracing paper to avoid eyestrain.

Protect your contour drawings with duplicates made using tracing paper and a lightbox.

Make your own light table . . .

. . . with doorstops and fluorescent lights.

Drawing Techniques: Tonal Blending

You're well on your way to mastering the drawing basics now—and hopefully your sketchbook is filling up! Now we'll take some time to look into some specific drawing techniques.

You can use several different techniques for developing the volume and dimension of a form. The first one presented here is tonal blending, which can be done both quickly for a sketch or more deliberately for a final rendering.

The idea of tonal blending is to produce a smooth, gradual transition from highlight to shadow. You can use rhythmic shading strokes, working hard to soft in graphite grades. Use the harder grades to produce the lightest values, then gradually transition to darker values with the softer grades. Another option is to blend strokes of graphite, charcoal or other carbon mediums with a stump, tortillion, chamois, brush or other blending tool. Remember that softer mediums blend more easily than harder mediums.

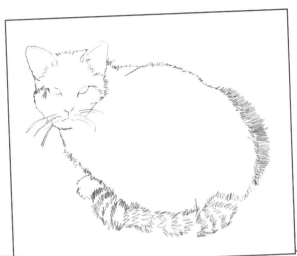

Begin with a contour drawing

To get started, create a detailed contour drawing and trace it onto several pieces of paper using tracing paper and/or a light table. See page 57 for tracing tips.

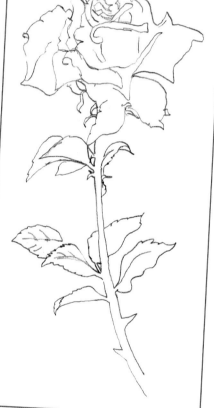

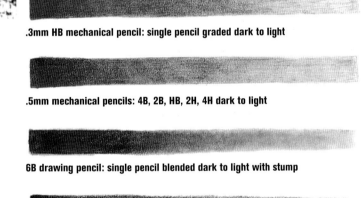

.3mm HB mechanical pencil: single pencil graded dark to light

.5mm mechanical pencils: 4B, 2B, HB, 2H, 4H dark to light

6B drawing pencil: single pencil blended dark to light with stump

Woodless graphite stick: 6B and HB blended with stump and brush

Charcoal: blended with a stump, brush and chamois

Felt-tip pens: gradation using black to light gray

Create value scales with tonal blending

Gather some drawing tools, including pencils of different grades, and some blending tools. You don't have to use the same tools used for the illustration above, but be sure you have a variety. Begin with a single pencil and make a smooth value transition from dark to light. Repeat this until you've created smooth transitions like the ones shown with the darkest dark and lightest light. Change tools and repeat the process. Creating value scales in this way with different drawing tools will give you the confidence to choose the best tool for each individual drawing.

Experiment with drawing paper

The tooth and weight—smooth or rough, heavy or lightweight—of the paper you use will affect the outcome with each medium. Explore a variety of papers to find your personal preference.

Experiment with drawing tools

You're mainly using pencils for the exercises in this book, but don't let that stop you from experimenting with other mediums. The diameter and shape of a medium's tip provide options for the style and width of a line. Mechanical pencils provide a constant tip diameter and shape. Wood-encased drawing pencils require constant sharpening (or you can have ready a number of sharpened pencils) to maintain a consistent tip shape and diameter. You can use a sanding pad to create a steady tip on a charcoal pencil or stick. Browse the art supply aisles, and test the possibilities!

Use tonal blending for photorealistic drawings

Tonal blending leads to more realistic-looking drawings and becomes a basis for interpreting values with other drawing techniques. In order to create drawings this way, you will need a blending tool. To create the rose, I used pencils graded from hard to soft as well as blending stumps. The stumps distributed the graphite smoothly to gradually move values to lighter areas while filling in the tooth of the paper. After you've achieved a smooth blend on a flower such as this, you'll have to use a pencil with a very fine point to fill in details and textures like the veins in the leaves.

Draw your cat

Cats are good subjects to work with as you explore the various drawing techniques. They don't mind having their pictures taken and tend to stay in one place long enough to sketch.

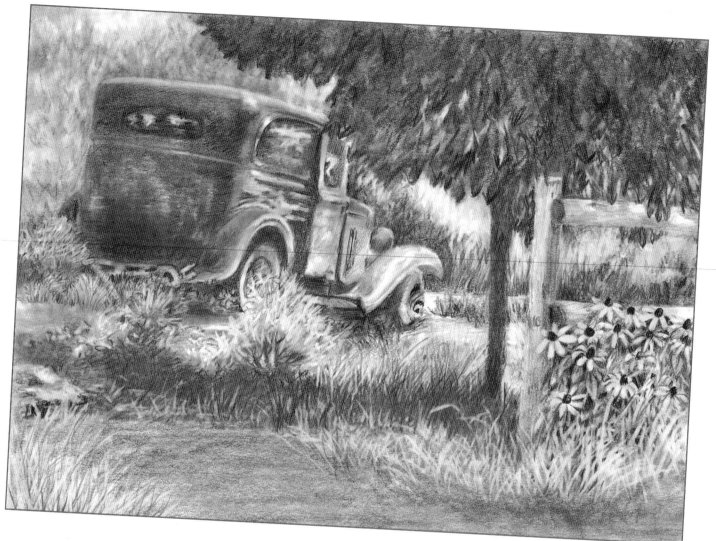

Explore value relationships with tonal blending

There's nothing like tonal blending to explore value relationships, especially in a more complicated composition such as this one. You can continue to add tone and blend from light to dark and from dark to light without worrying about saving all the highlights. Once you've achieved smooth, gradual transitions, use a stick eraser or a kneaded eraser sharpened to a point to recapture the highlights.

draw now!

1 Using different grades of graphite, create two series of five-step value scales with tonal blending. In one, blend only with pencil strokes, and in the other use blending tools.

2 Create a tonally blended image that uses a five-step value scale.

3 Use the tonal blending technique on one of the contour drawings you prepared on page 58 to create a drawing using dark values and recapturing lights with a kneaded eraser or eraser stick.

Drawing Techniques: Random Line

Random lines are useful for quickly developing the light and shadow areas on a subject. With this technique you can create a value study that expresses an animated, energetic and lively subject. The freedom and the relaxed motion of this technique makes it an effective way to develop an understanding of the image before starting a final rendering. Consider using this technique as part of your gesture-drawing exercises.

The style of random line—scribbled, straight or circling—whatever motion you use should be one that comes naturally to you. Whichever style you choose though, use it consistently. If you begin with a scribbled line, use a scribbled line throughout the drawing. The style consistency will hold your drawing together. Do several random line drawings to get to know your own personal method and style.

How to Create Random-Line Drawings
Make a continuous line with a random motion without lifting the pencil. The density of the line mass you create determines the value gradation.

Graphite

Technical pen or felt-tip pen (fine point)

Felt-tip pen (medium point)

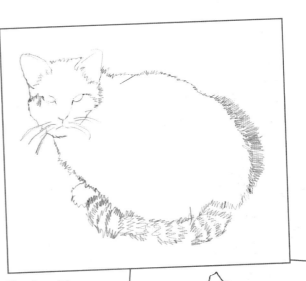

Create value scales with random lines
Gather various drawing tools, including pencils of different grades. Random-line drawing doesn't call for any blending. You don't have to use all the tools used for the illustration above, but be sure you have a variety. Begin with a single pencil and make a smooth value transition from dark to light. Repeat this until you've created a smooth transition like the one shown with the darkest dark and lightest light. Change tools and repeat the process.

Begin with a copy of your contour drawing
Get out one of the contour drawings you created for exercise 20. Use your style of random line to define the volume form of your subject using the density of line to depict value change from highlight to shadow.

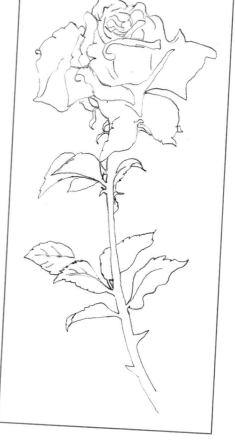

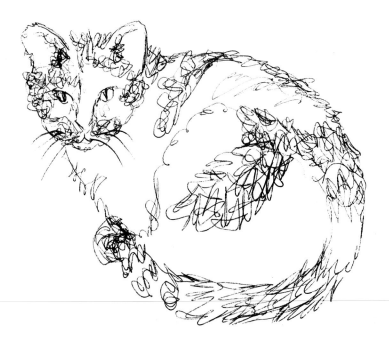

Use random line to communicate

Random-line drawing is great for communicating the character of a subject. In this drawing the line emphasizes my cat's very feline arrogance.

Use random-line for a lighthearted effect

Because random-line drawings appear less sophisticated than those done with tonal blending, you can use the technique to achieve an informal, lighthearted effect. This drawing of the rose is drastically different from the one on page 59 done with tonal blending, which appears more polished and formal.

Use random line to express character

With random line, you're almost forced to express your spontaneous response. The technique used here on the old, rusty, weathered car produces a sense of character as well as texture as the line follows the shapes of highlight and shadow. This sort of expression can't happen as readily with other techniques.

Convey your own response with random line

Line travels easily from one object to another in random-line drawings to unify objects such as the butterfly and flowers. As you develop your own style of random line, you will be able to convey your feelings about the subject more easily.

Use random line for value studies

Random line is a natural technique for creating quick value studies. The rhythm of the stroke as you create random-line drawings produces a flowing movement that captures the playful mood of the gesture and setting, as in this sketch.

draw now!

1 Create random-line value scales using different styles of line to see which feels the most natural to you.

2 Adapt one of your contour drawings into a value study using random lines.

3 Use a drawing made with tonal blending as the basis for a random-line drawing.

Drawing Techniques: Hatching

Another way to create quick value studies is to use parallel or *hatched* lines. With this drawing technique, you vary the line thickness and spacing to define light and shadow. There is no blending with hatched lines, so you can use virtually any drawing tool you like: pencil, charcoal, pen and ink, or felt-tip pens.

How to Create Hatched Drawings

Use thin lines and/or lines spaced far apart for light or highlight areas of the drawing. Apply thick lines and/or lines close together for dark or shadow areas. Make your lines straight, curved or angled to emphasize or accent the shape of an image. Use line density to develop the image's volume and dimension.

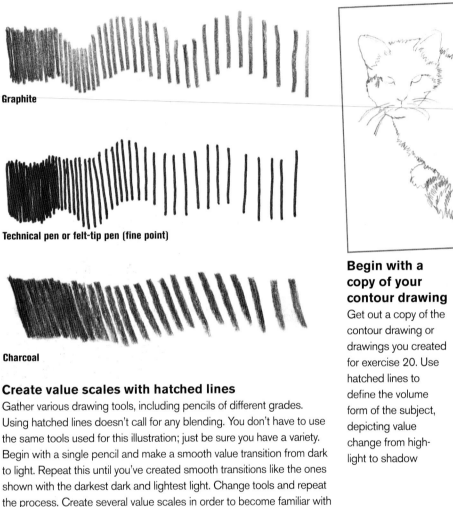

Graphite

Technical pen or felt-tip pen (fine point)

Charcoal

Create value scales with hatched lines

Gather various drawing tools, including pencils of different grades. Using hatched lines doesn't call for any blending. You don't have to use the same tools used for this illustration; just be sure you have a variety. Begin with a single pencil and make a smooth value transition from dark to light. Repeat this until you've created smooth transitions like the ones shown with the darkest dark and lightest light. Change tools and repeat the process. Create several value scales in order to become familiar with your drawing instruments.

Begin with a copy of your contour drawing

Get out a copy of the contour drawing or drawings you created for exercise 20. Use hatched lines to define the volume form of the subject, depicting value change from highlight to shadow

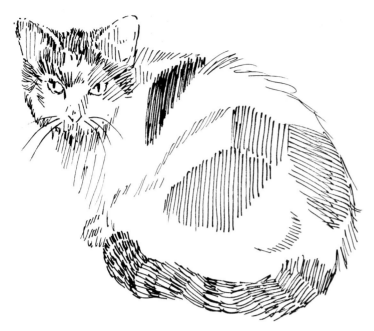

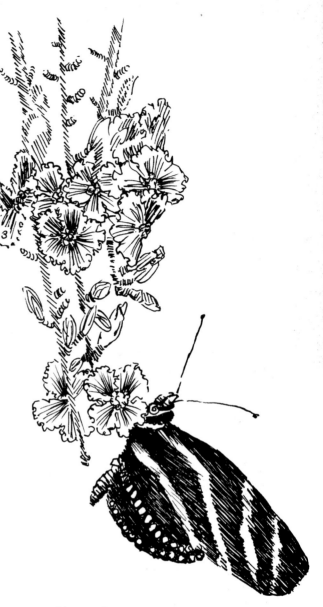

Hatched lines provide a harder edge

These hard-edged, hatched lines produce a more aggressive version of the cat than the soft tonally blended drawing or the casual random-line drawing. Deliberate strokes in darker values are more aggressive than softer strokes in light values no matter what technique you use.

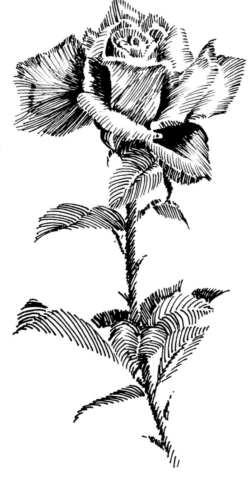

Hatched lines should always conform to your subject's shape

The hatched lines give this rose a decidedly graphic style, like one you might find in clip art. Allow the hatched lines to conform to the subject's shape to add to the dimension and volume of the image. Notice how some of the rose's hatched lines curve.

Line style conveys a feeling

The density (closeness) of hatched lines creates tonal variation. While the random-line drawing of the butterfly and flowers on page 63 stressed the unity of the two, this version makes them seem quite separate. The line you choose will affect the outcome of your drawing. If you're proficient at multiple techniques, you can choose the technique that best suits your subject and the feeling you want to convey.

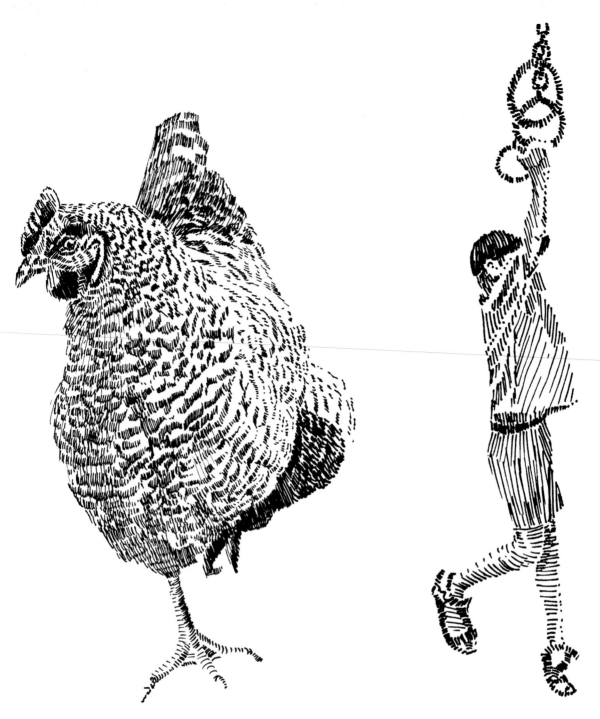

Try hatched lines with technical pens

I used technical pens in three different sizes to create this drawing of a Barred Rock Hen. I allowed the hatched lines to follow the form of the hen's physical surface structure. The size of the pen along with the density of the line helped me produce variations in light and shadow and the effect of volume, and to create the details of her feathers, beak, feet and comb.

Different techniques affect your drawing's flow

A vertical contour drawing gained visual flow with its translation into this hatched drawing. The movement from ring to ring is exaggerated by the direction of the hatched lines.

draw now!

1 Create at least three value scales with hatched lines using a different medium for each scale.

2 Use one of the drawings from exercise 20 and fill in the values to create volume with hatched lines.

3 Using hatched lines and several different mediums, create rough value studies of objects around you.

Drawing Techniques: Crosshatching

Crosshatching is similar to hatching, except crosshatching involves placing another set of hatched lines across the initial set of hatched lines. The width and spacing of the crosshatched lines creates a value gradation to define light and shadow on the subject as well as volume and dimension. Almost any medium works well with this technique.

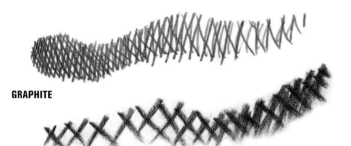

GRAPHITE

CHARCOAL

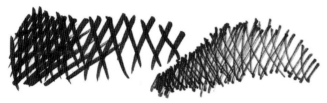

TECHNICAL PEN OR FELT-TIP PEN (FINE POINT)

Create value scales with crosshatching

Gather various drawing tools, including pencils of different grades. Crosshatching doesn't call for any blending. You don't have to use the same tools used for the illustration above, just be sure you have a variety. Begin with a single pencil and make a smooth value transition from dark to light. Repeat this until you've created a smooth transition like the one shown with the darkest dark and lightest light. Change tools and repeat the process.

Begin with a copy of your contour drawing

Get out a copy of the contour drawing or drawings you created for exercise 20. Use crosshatching to define the volume form, depicting the value changes from highlight to shadow.

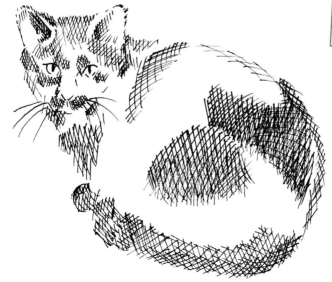

Use crosshatching to limit detail

Crosshatching simplifies value studies and limits detail, allowing you to take a more general view of your subject. I used only one size pen tip for this pen-and-ink version of the cat. This placed limitations on my control of the value transitions and produced harder edges. For more refined and gradual value gradations, use several different pen sizes.

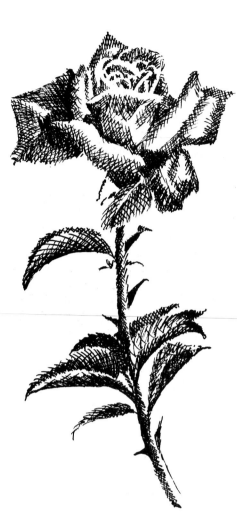

Use crosshatching to enhance detail

Using a .3mm mechanical pencil with HB graphite allowed me to increase the detail in the butterfly. The fine tip and light value this pencil provided enabled me to create soft edges with short, crosshatched strokes. For dark values and details, I simply added cross-hatched layers until I built up the correct tones.

Try using one pen only

A technical pen of only one size creates a coarse version of the rose. Notice how much harsher the petals appear.

Use archival-quality paper

Since you never know when you'll come up with a drawing you want to keep, it's best to use archival-quality paper all the time. This paper is acid-free, and when properly cared for, doesn't yellow, become brittle or spot with age.

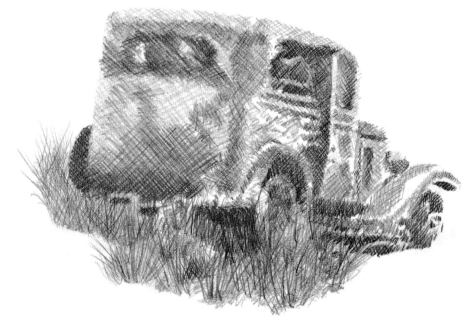

Gather several different pencils for the most flexibility

Crosshatching with different grades of graphite lead gives you even more flexibility to create value gradation. I used several different grades and tip diameters to emphasize the old car's weathered surface and create a soft-looking drawing.

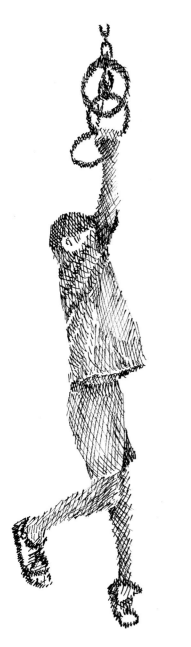

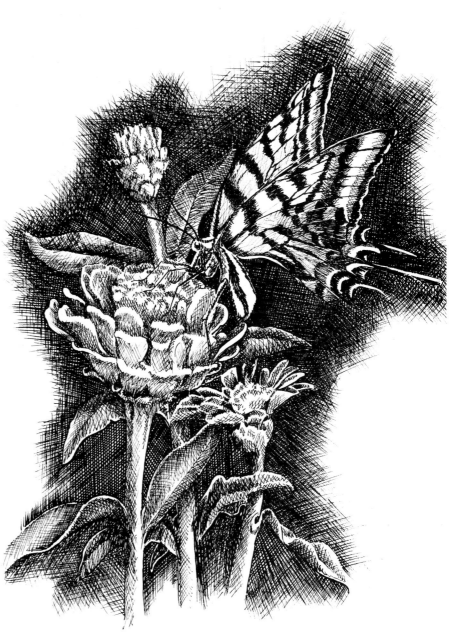

Get out those blended drawings
Use the value studies you did with tonal blending as references as you practice crosshatching, as I did to create this drawing. As you practice the different techniques, pay attention to which techniques feel most natural and comfortable. That's how you'll discover your own style and preferences.

Try different strokes for varied effects
Give your strokes a soft edge by firmly placing your pen at the beginning of a stroke and lifting it at the follow-through. All your crosshatched lines shouldn't look the same. Use several different patterns of crosshatching to give your drawings texture and interest. I used different-sized Faber-Castell PITT artist pens to create this vignette from a photo of my garden.

draw now!

1 Create several different crosshatched value scales using different drawing tools with different-sized tips.

2 Add crosshatched lines to one of your hatched-line drawings from exercise 22.

3 Go over one of your pencil crosshatched drawings with a technical pen or other pen. Erase your pencil lines afterward. Was the ink drawing easier to do with the pencil lines to follow?

Drawing Techniques: Pointillism

Pointillism uses dots to establish values. Dots placed close together create dark values; dots that are widely spread produce light values. Technical pens or felt-tip pens are most effective for this technique, but you can use almost any medium, including pencils. When you use technical or felt-tip pens or even brushes with ink, the size of the tip will determine the size of the dots and your values. Smaller tips tend to produce a more refined drawing that has greater detail and value gradation.

Technical pens

Felt-tip pens

Create value scales with pointillism

Gather different drawing tools, including markers and some pencils of different grades. You don't have to use the same tools used for the illustration above, just use a variety. Begin with a pen or pencil and make a smooth value transition from dark to light. Repeat this until you've created a smooth transition like the one shown with the darkest dark and lightest light. Change tools and repeat the process.

Begin with a copy of your contour drawing

Get out the contour drawing or drawings you created for exercise 20. You can place the dots over the contour drawing. You can even begin adding value with tonal blending in pencil. Use ink to place dots over that, then erase the pencil when you're finished.

Try this

Create a shaded value study with a pencil. Use a felt-tip pen and pointillism to apply value right over the pencil study, then erase the original pencil marks.

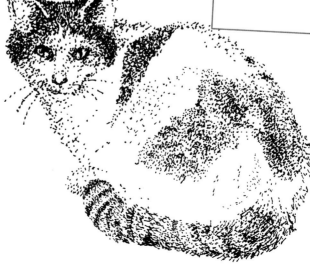

Use a range of tip sizes & styles

The size and style of your pen determines how refined an image you can create with pointillism. And as with other techniques, you get the most freedom using several different sizes and types. I used small tips to create the lighter values in the cat and larger tips for the darker values.

Make a value study before beginning pointillistic drawings

You'll have a much easier time creating pointillistic drawings if you do a value study first. You can use the value study as a reference. If you create your value study with graphite, you can place ink dots right on top of your value study and erase unwanted tones. Whatever you do, don't skip the value study. Making one will save you time in the long run.

All ink is not equal!

If you begin using ink, be alert to its lightfastness and waterproof permanence before creating a final rendering. Inks that are not pigmented will bleed out from the dot, creating a less effective drawing.

Create light values with white space

Pointillism tends to work better for dark values than light ones. Sometimes you can establish light values without using any dots though. I used that technique to create the dark butterfly with the white stripes.

Get good ink results without expensive tools

You don't have to spend a lot of money on special pens as you're experimenting with different drawing tools. I did this drawing with an inexpensive medium-point felt-tip pen. While the large tip size allowed for less detail and the ink tended to bleed out at the edge, I was still able to create value and form. To make sure that your ink doesn't bleed out from the dot, make sure the pen has pigmented ink.

Do multiple studies of the same subject

Because I had re-created this subject several times using different drawing techniques, this pointillistic study came easily. No matter how much experience you gain as an artist, you'll always find that repetition is the best teacher.

Keep practicing with different techniques

As you gain experience with different drawing techniques, you'll be able to draw more-complex subjects. Notice how the light areas contrast with the shadow shapes. Use different sizes of pen tips to gain the most control of the value gradation. The large tips helped me easily create the dark shapes, while the smaller tips helped me define and soften the light values.

Be careful with that eraser!

Erasers can compress or change the tooth of the drawing paper and affect the way the medium adheres to the paper.

draw now!

1 Use pointillism and a selection of felt-tip pens or technical pens to create a value scale.

2 Create a value study with graphite. Use a pen to apply values using pointillism over the graphite; then erase the graphite.

3 Choose a contour drawing from a previous exercise to develop a pointillistic value study.

How to Plan Your Drawings: Focal Point

By now, your sketchbook should be brimming with studies, blind contour drawings and maybe even some finished drawings. It's time to begin thinking about the *composition* of a drawing: how it should be arranged. Successful drawings are well thought out. Don't be a slave to a photo reference or subject; you are the artist and you have the final say in deciding what goes where.

A good place to begin is the focal point, the subject of a composition and the most important part of the drawing. Place that image in the most strategic place. The standard way to do this is to use the *rule of thirds*: Divide your format (the size or shape of the format is irrelevant) into thirds both horizontally and vertically to create a grid that identifies four cross points. The area around any one of the four cross points can become a strategic position for the focal point.

Position the images to create flow and transition from one area to another and to keep the viewer's eye moving within the format. The viewing path should stay within the composition. Avoid pointing an image out toward the edge of the format or out of the visual flow of the composition, thus directing the viewer out of the drawing. Carrying an image to the edge of the format creates a more dramatic effect and allows the viewer's imagination to complete the image.

Use Thumbnail Sketches to Experiment

Thumbnail sketches are small, simple drawings that allow you to explore possibilities for shape, size, orientation and focal point placement. You'll find the thumbnail sketch key to planning your compositions. Use simple thumbnail sketches to explore format orientation with different possibilities of focal point placement.

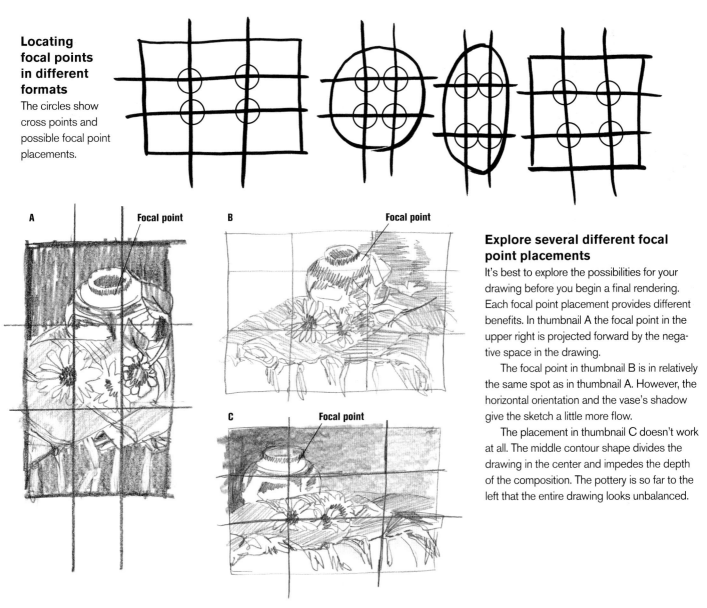

Locating focal points in different formats
The circles show cross points and possible focal point placements.

A

Focal point

B

Focal point

C

Focal point

Explore several different focal point placements
It's best to explore the possibilities for your drawing before you begin a final rendering. Each focal point placement provides different benefits. In thumbnail A the focal point in the upper right is projected forward by the negative space in the drawing.

The focal point in thumbnail B is in relatively the same spot as in thumbnail A. However, the horizontal orientation and the vase's shadow give the sketch a little more flow.

The placement in thumbnail C doesn't work at all. The middle contour shape divides the drawing in the center and impedes the depth of the composition. The pottery is so far to the left that the entire drawing looks unbalanced.

Avoid the bull's-eye effect

Isolating a focal point by placing it in the center of a drawing or by leaving a space around the entire focal point produces a target-like effect that limits a viewer's interest.

Move the focal point for immediate improvement in a drawing

By placing the same focal point near a strategic cross point and by either touching the format edge or adding counterpoints (see exercise 26), you can achieve better visual flow. The drawing becomes a much more interesting and successful work of art.

Poor flow

In this thumbnail, the teapot directs the flow out of the drawing.

Good flow

The visual flow in a drawing should remain within the confines of the format.

Simplify your subject to analyze flow

The simple shapes and tones gave me the information I needed to create further studies.

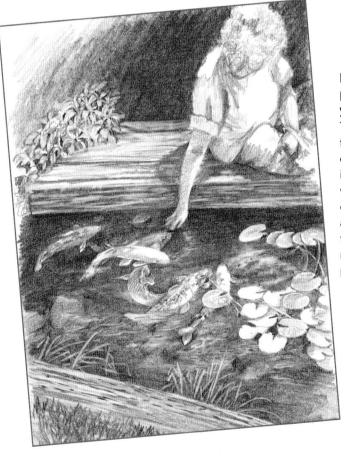

Begin thinking about focal-point placement as you study your subject

This composition in progress establishes the focal point in the upper-right quadrant, with a dark background and light values for the image. The shapes and values of the koi fish, water lily leaves, wood pier and leaves at the edge of the pier establish the setting and create a visual path through the composition. The triangular shapes of the grass and the wood rail at the water's edge help to define the composition's depth.

draw now!

1 Use different format orientations and sizes to create thumbnail sketches for placing focal points.

2 Create four thumbnail sketches in the same format size and shape, changing the placement of the focal point in each study to a different cross point area.

3 Choose one of your thumbnail sketches and rework it using values to make the focal point stand out and to manipulate the flow.

How to Plan Your Drawings: Counterpoints

Counterpoints are secondary areas of interest. They produce balance and support for the focal point. The placement of the focal point and its relationship to the counterpoints creates the visual path that flows through a composition and holds a viewer's interest, providing areas to rest, reflect and identify with the drawing.

Once you've chosen the subject, format (size, orientation, drawing surface) and focal point, it's time to choose your counterpoints. You should always use an odd number of counterpoints—for example, three, five or seven—overlapped and varied in size and shape, to develop the theme of the composition, produce a feeling of dimension and emphasize the focal point.

A good visual path includes one entry point and a rest stop at each counterpoint as they eye flows through the composi-tion. The entry point first attracts the viewer and is normally the area of lightest value. More value contrast emphasizes the focal point while less contrast establishes the supportive counterpoints.

Analyze the positions of the focal point and counterpoints in the series of thumbnails on this page. Notice the changes made to improve the composition structure.

With thumbnail sketches, explore your own compositional possibilities before you begin any final drawings. This planning stage will save you time in the long run by keeping you from discovering problems while you work on a final rendering. Once you've settled on a thumbnail for your subject, begin your final drawing using the thumbnail as a road map.

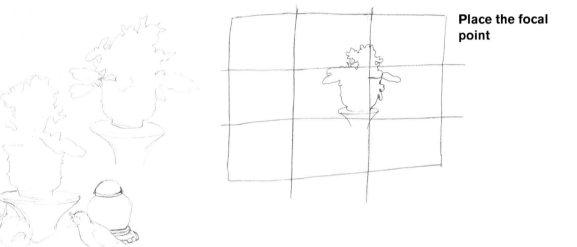

Place the focal point

Create studies of the subject

Establish the counterpoints

Crop to improve the structure

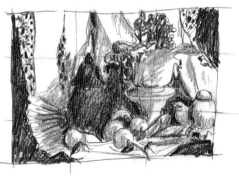

Create value studies

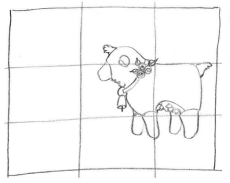

Think ahead as you place the focal point

I thought placing this focal point in the lower-right quadrant would give me some nice options for placing the counterpoints.

Sketch in the counterpoints

Counterpoints should support the focal point and add interest and balance while they direct the visual flow. The books under the toy sheep provide a stepping stone to the crayons, flowers and wall covering, and the books redirect attention back to the focal point.

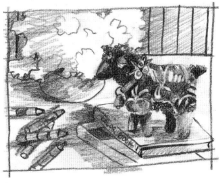

Begin a value study

A simple value study establishes the position of the darker value—the toy sheep—as the focal point in contrast with the lighter values around it. Imply shadow areas with middle values at this stage. Keep competition with the focal point to a minimum by using less contrast and detail for the counterpoints.

Use background images to project the focal point

This thumbnail study develops the focal point between the upper-right quadrant and the lower-left quadrant. It establishes the visual flow between the two images with the area behind used to project the focal areas and define the setting.

A dark background projects light focal points

Just as dark values defined and distinguished the sheep as the focal point of the first study on this page, dark backgrounds can project forward a light focal point, such as the children's faces.

Don't place horizon lines in the middle of the composition

Use the rule-of-thirds grid to help you place the horizon line (where the sky and ground meet) for landscapes. Don't place that line in the middle of your composition. Here, I used the upper two-thirds of the drawing for sky shapes.

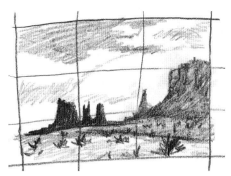

Try a three-step value scale to place shapes and contrast

Three values should be enough to organize your drawing. Here the darkest area defines the focal point, while the areas with lighter values and less contrast and definition become the counterpoints. The middle values in the sky provide movement, aiding the flow of the composition.

draw now!

1 Create a thumbnail sketch to identify placement of a focal point with at least three supporting counterpoints.

2 Use a three-step value study of the thumbnail to establish with value contrasts the dominance of the focal point.

3 Create a more developed value study (use more than three values) to reinforce your choice for the focal point. Create visual flow with your counterpoints.

How to Plan Your Drawings: Line

Composition begins with your response to a subject. You express that response with line, because the technique you use to produce line communicates a message. A strong, deliberate line expresses a different feeling than a line made with a cautious, less dramatic effort.

With daily practice, your line style will continue to develop so that you can convey your personal response with greater security. Once you've drawn a subject to your satisfaction, that positive experience will lead to other positive experiences and develop your drawing confidence. Set goals and allot daily drawing time, and you will see results.

Consider line orientation, or the direction or shape of your lines, as you explore compositions with thumbnail sketches based on contour drawings. Whether we realize it or not, line orientation often creates an emotional response.

Maintaining continuity of line is important to lead viewers into and through a composition. An incomplete line disrupts the flow and causes confusion. Consciously strive for follow-through in each line of your drawings.

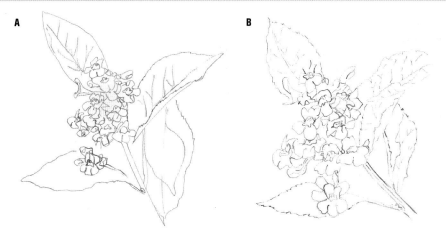

A B

Be bold with your drawings
Striving to create an accurate drawing sometimes results in timid, boring lines like those in drawing A. Your drawings should convey an emotional response to your subject. Let yourself go a little bit so you can produce a more interesting and honest representation, such as drawing B.

Diagonal line
A diagonal line produces a feeling of discomfort, angst, tension, uneasiness, apprehension or fear. Here, it suggests tension, initiates a feeling of forceful movement against the water, and defines the position of the light source.

Horizontal line
A horizontal line suggests a soothing, peaceful, relaxing, tranquil and restful mood. The same subject with a horizontal line expresses quiet and calm.

Vertical line

A vertical line communicates stability, steadiness, permanence, silence, tranquility, strength and consistency. Combining a horizontal and a vertical with diagonal lines, the example at the far right conveys the stability of the horizon and the strength of the figure, along with the motion of hair blowing in a breeze and water lapping at the shore.

Radiating or converging lines

Lines that radiate communicate vigilance. Lines that converge naturally create focus. Radiating or converging lines attract and hold interest, especially in landscape or floral compositions.

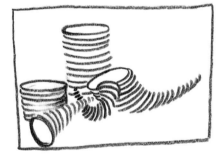

Zigzag lines

Repetition of zigzag lines generates movement that creates excitement, agitation and turmoil.

Curved lines

Curved lines with systematic repetition create harmony, synchronizing to coordinate and organize the volume or motion of an image.

Wavy lines

Wavy lines flow to produce a rhythmic, tranquil, graceful motion.

draw now!

1 Create a thumbnail sketch using wavy lines to indicate the movement of water. Then create a sketch using curved lines to indicate the volume of a shape.

2 Create a contour drawing with expressive line. Use more pressure for shadow areas and less pressure to define lights and highlights.

3 Use only line to create drawings like those on this page to express the following: anger, tranquility, joy, sadness, hot, cold, awake and asleep. Can you think of any more opposites to draw?

How to Plan Your Drawings: Space

Space appears initially as an abstract form that can be thought of as positive (the named space) or negative (the area around the named space; see page 32). Space attracts a viewer to a composition before details are distinguishable. Use thumbnail sketches to plan simple basic divisions of space. Keep space divisions to odd numbers for the most interesting and effective drawings. Even-numbered space divisions tend to produce unwieldy and awkward symmetry, inhibiting a smooth, interesting flow through a composition.

Identify the positive and negative spaces in the thumbnails on this page, then in your own drawings. Analyze and evaluate the space divisions for line quality and form.

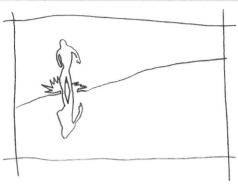

Simple space divisions
How many space divisions can you find in this thumbnail sketch? Notice how simple space divisions of the man walking in the water are easy to identify. This emphasizes the focal point.

Forming a cohesive drawing from more complex space divisions
This thumbnail from exercise 27 is divided into three more intricate and complex spaces. The other illustrations on this page show how each of these should relate to the others and how they can work together to emphasize the focal point.

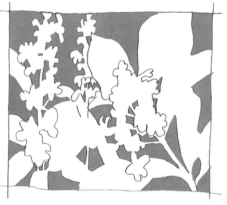

Space division 1: the background
Values in the background should propel all the other shapes in your drawing forward.

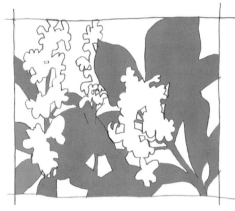

Space division 2: the leaves
The overlapping shapes of the leaves and flowers create degrees of depth. The spaces between the flowers and leaves allow the background to peek through, adding more depth.

Space division 3: the flowers lead to the focal point
The flower clusters serve as the main focus of this drawing. Notice how they are distributed throughout the picture plane. The circled focal area will be distinguished from the other flowers with more definition, contrast and detail. Studying shapes in this way allows you to approach your final drawing with a definite road map. There are three main space areas to deal with—foreground, middle ground and background—and the focal point will stand out against them all.

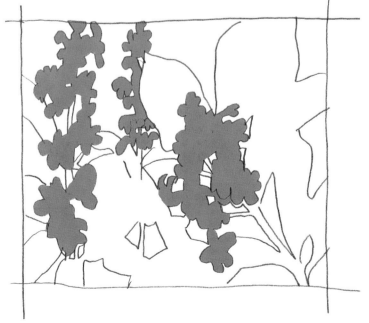

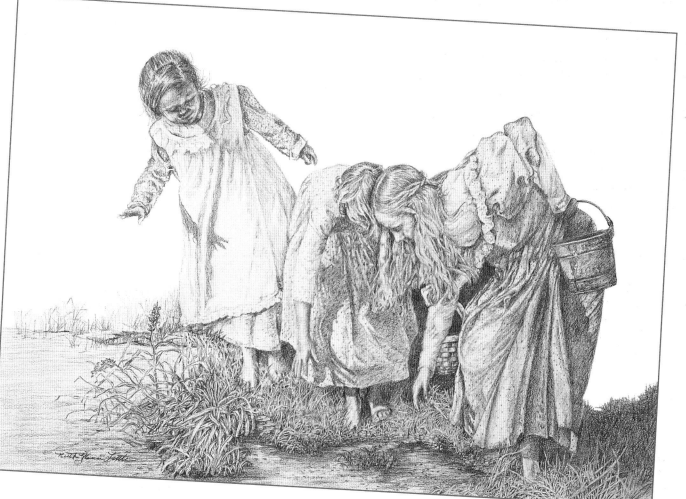

Use positive and negative space divisions to project the subject

There are three space divisions in *Tadpoles*: the space behind the girls, the space of the girls and the space of the grass and water under the girls. The positive space of the girls is dominant so the negative space behind them becomes important for projection. The middle-to-dark values of the girls against the lighter value of the sky provide contrast to define the girls' shapes.

TADPOLES
Graphite on Stonehenge drawing/printing paper
15" × 22" (38cm × 56cm)

draw now!

1 Use thumbnail sketches to plan a drawing. Identify and refine positive and negative shapes to create engaging forms.

2 Adjust the negative shapes in your drawing until the positive shapes appear correct.

3 Using the same drawing, create a series of thumbnails that experiment with the visual flow of the composition by increasing and decreasing the value contrasts between the positive and negative shapes.

How to Plan Your Drawings: Planes

When I refer to planes, I'm talking about the dimensional space or positions of shapes within a drawing. The number of planes possible in a composition is unlimited, but you'll always have three fundamental planes: foreground, middle ground and background.

Planes are present in every composition—still lifes, landscapes, portraits—whatever. Detail, contrast, and the size and shape relationships among objects communicate their plane positions as they overlap, project and recede. Background shapes the farthest away are diminished in size, value and detail. The middle ground and foreground emerge naturally as you make adjustments to background objects.

Define planes with overlapping and interlocking shapes

Overlapping and interlocking shapes (1) define the progression of planes from back to front. Shadows between the interlocked shapes project the sphere in front with the contrast of the darker sphere behind it (2). The detail of the value gradation of the front shapes is more pronounced (3) and as shapes recede, the detail in their value gradations decreases (4).

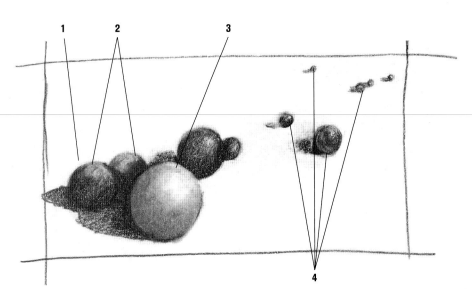

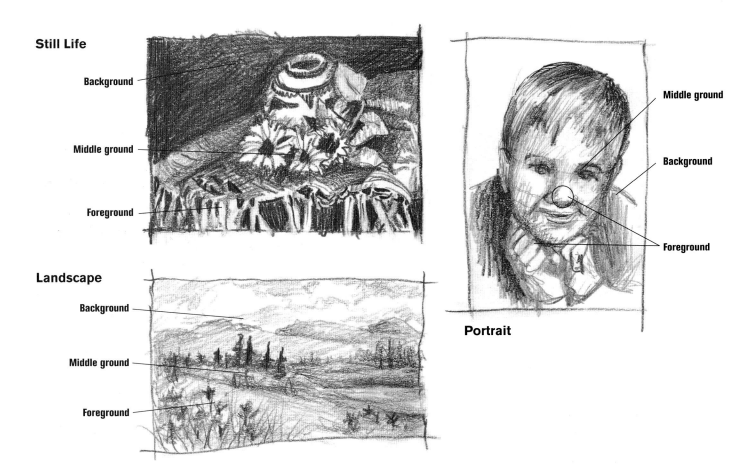

Still Life

Background

Middle ground

Foreground

Landscape

Background

Middle ground

Foreground

Portrait

Middle ground

Background

Foreground

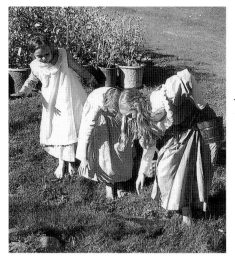

Reference photo for *Tadpoles*

Use blind contour drawings to identify planes

Indicators in the contour drawing—clues to dimensional lines—set up the progression of planes to separate overlapping and interlocking shapes.

Here, the first plane is indicated by the outline of the hand and at the point where the two heads overlap (1). That hand and the foremost hand will be projected by the shapes behind. The second plane is indicated where the hand overlaps the dress (2), with the third indicated by the foot the dress overlaps (3).

Blind contour drawing with dimensional lines

Dimensional lines, enhanced with the first steps of a value study, separate the images and clarify the first (1), second (2) and third (3) planes of the overlapped shapes inside the contour. You can already tell which little girl is farthest back in the drawing.

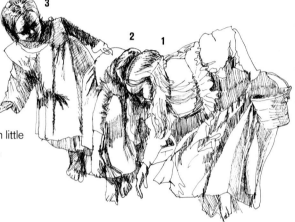

Add value and contrast to clarify planes

Adding contrast and value identifies the light source, and developing shadows from back to front further defines the dimensional planes. In order to expand this value study to explore composition, I added grass, a waterline and a potential orientation (vertical).

The value study is the place to experiment with plane and projection using value contrasts, highlights and shadows to separate the shapes. Notice how the foremost image contains the most contrast and detail. A shadow separates the second image from the first, beginning at the heads to define the hair and continuing down the arm with shadow shapes. The reduced contrast between the second image and the third allows the third to recede behind both the images in front.

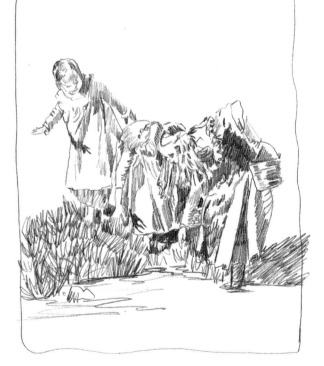

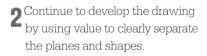

draw now!

1 Use any one of your old contour drawings, or create a new one. Add to it dimensional lines that help identify the foreground, middle ground and background.

2 Continue to develop the drawing by using value to clearly separate the planes and shapes.

3 Use gradation of detail and value contrast to diminish the planes that recede into the background.

Use Value to Direct the Viewer's Eye

In exercise 26, you learned that the entry point to a drawing is normally the area with the lightest values. Now it's time to take that concept one step further. Value and contrast produce the visual flow in a composition, beginning with that lightest-value entry point on a path leading to and from the focal point. As you explore space, planes, shape and texture in thumbnail sketches, also consider how value will affect your composition.

Apply lights against darks and darks against lights to project images forward in your drawings. Do several thumbnail sketches to explore the path in abstract form before refining that path in line drawings.

By increasing your ability to manipulate values to emphasize and arrange objects in drawings, you will quickly expand what you can do. Study these thumbnail sketches of Gambel's Quail to learn just a few of the possibilities for contrast and value to project and feature the focal point.

Plan using lighter values

In this value plan, which uses primarily middle and light values, the eye is attracted to the image with the most value contrast and detail: the foremost quail. The quail shapes with fewer, more subtle value contrasts and detail are clearly behind the focal point. They project the main quail forward while serving as counterpoints and creating visual flow.

Create a path with lighter values

The light values behind the crowing quail project him as the focal point. The lighter value of the stream creates an entry point to the the visual path leading first to the group of quails, then through the sagebrush to the the crowing quail. As counterpoints, the smaller quails have less contrast and detail, which transfers attention to the crowing quail.

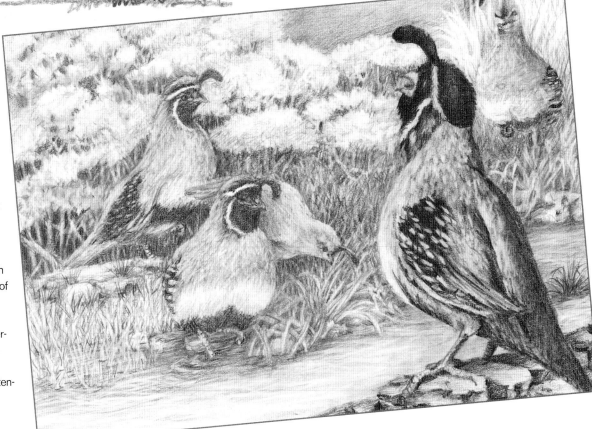

Plan using darker values

The focal point in this study dominates and is projected due to its size, detail and value contrasts. However, it's also propelled forward by the strong, contrasting dark background. The abstract negative shapes break up the value plan into three strong shapes, creating great visual flow early on.

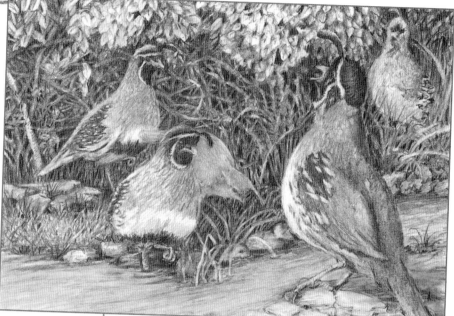

Less contrast, less depth

The entry to the second composition begins with the leaves rather than the stream, changing the visual flow through the composition. The darker values of the second rendering also project the crowing quail with contrast and comparison, but because the value and amount of detail in the counterpoints is similar to those in the focal point, the focal point stands out less, creating less depth in the composition.

Make the focal point the star

Several thumbnails may be necessary to find the most appropriate arrangement. Once you've made your choices, develop your focal point. Decide how you will distinguish your focal point with detail, and develop value contrasts to emphasize the focal point. Add just enough value contrasts and detail to the counterpoints to develop depth and dimension but not so much as to compete with the focal point.

draw now!

1 Use a contour drawing with dimensional lines added to develop a series of thumbnail sketches that experiment with possibilities for visual flow.

2 Do another series of thumbnail sketches that experiment with value contrasts that project the focal point.

3 Create two value studies of a composition: one using a light background and another using dark values for the background.

Moving On

Congratulations! You've done it. You've made your way through all the Draw Now! exercises, from blind contour drawings to composition planning. Repeat these exercises often. Repetition will give you confidence and make a real difference in your progress as an artist.

Eventually, the drawing process will come to you naturally. The blind contour drawings you've practiced will make you a keen observer who is able to transfer observations to paper. You'll automatically find basic shapes in your subjects and assign to them tones and values. If you practice these exercises regularly, you will be rewarded. Your drawings will evolve without your thinking about the process; you'll focus only on the outcome.

The drawing process provides a starting point as you perceive the world around you and begin to communicate your responses. But as you consider composition and how a final rendering communicates, you will begin a new role. Not only will you draw automatically by choosing and placing focal points, considering counterpoints, negative and positive space, and plane positions defined with detail and value contrasts; your daily life will become richer as you use your new sense of observation and awareness of your surroundings.

And now, you can begin to truly express yourself in your drawings!

The drawing process

Eventually, blind contour drawings will become second nature and you will easily gain concentration when you draw. You won't even notice that you spend more time looking at your subject than at your paper. Until then, you're learning to see and building image memory. Eye-hand coordination requires constant practice. Keep at it! I promise you'll enjoy drawing success.

1 Create at least three blind contour drawings.

- Define the silhouette to initiate foreshortening.
- Establish relationships among grouped shapes or images.
- Acknowledge the surface texture and create indicator lines for division of shapes and dimension.
- Choose one contour drawing to use as you continue to step 2.

2 Begin adding details.

- Add dimensional lines and identify shapes within the contour.
- Identify basic shapes and volume forms within the contour to clarify how light and shadow will develop volume and dimension.
- Look for negative space and shapes to assess and adjust the contour shapes.

3 Create a value plan and assign values to develop the drawing.

- Consciously choose values to use, and establish a consistent value pattern of highlights and shadows in basic shapes.
- Create value gradation from shadow to highlight in your shapes.
- Evaluate the light and and dark values. Are they correct? If not, alter them.

4 Develop the surface character and edges.

- Use light and shadow to define and bring out the texture of each shape in your drawing and to further enhance the volume and dimension.
- Use value contrast to create, for interest and balance, a variety of hard, soft and lost edges.

Experiment With Other Drawing Tools

Now that you've spent some time with your pencils and paper, consider experimenting with other drawing tools. Charcoal, carbon and Conté crayon are inexpensive mediums that you can use easily and quickly to develop sketches. Inexpensive paper such as newsprint or manila is great for repeated efforts and encourages freedom and spontaneity. Final renderings are feasible with all three of these mediums as long as you're using acid-free papers with good tooth and strength for erasability.

Natural charcoal erases easily with any type of eraser. Processed charcoal and Conté are more difficult to erase. The rich, dark values are graded in value by softening lines and gradual blending. Use a separate blending tool for each value or color. Read on for more about charcoal, carbon and Conté, as well as some other drawing tools you may not have thought of.

Charcoal

Charcoal is a form of carbon produced by heating wood in an enclosed space without air. Natural charcoal sticks are made from vines or willow branches. These sticks come in thin, medium, thick or extra thick and range in diameter from 3mm to 24mm.

Compressed charcoal, a mixture of ground charcoal and additives, also is heat processed. Smoother and cleaner but more difficult to erase than natural charcoal, compressed charcoal is less delicate than natural charcoal and comes in both stick form and wood- or paper-encased pencils. Charcoal pencils are graded as light, medium and dark or as grades HB through 6B. Black charcoal is most common, but you can also find white and colors.

Charcoal sticks are sold by the piece, by the box or as an assortment.

Vine or willow charcoal
Natural charcoal sticks are easier to erase than compressed charcoal, but they also break very easily.

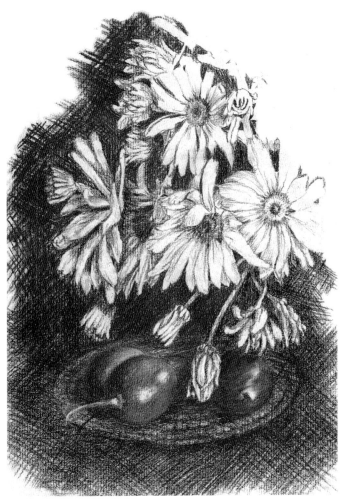

Multiple techniques and effects are possible with charcoal
Charcoal is an extremely blendable and versatile medium. Taking advantage of the toothy nature of charcoal paper allowed me to create this extremely textured drawing without a lot of fuss. Use harder grades of charcoal for your initial contour lines and value plans; then use softer grades to punch up the darkest values and shadow areas.

Softer grades of charcoal fill the paper tooth more quickly and create darker, richer blacks. Filling the background with crosshatched strokes of the softer charcoal created instant contrasts with both the light values of the daisies and the smooth, tonal blending in the tomatillos (the focal point).

Conté Crayon

Conté is a mixture of clay, pigments and carriers such as gum, grease or wax. It's compressed to produce a medium known for its colors, rich values and strength, even in thin, stick form. Its ability to withstand stroke force and pressure without breaking provides for fine detail and clean edges. Graded from H to HB (hard) and F to BB (soft), Conté comes in square and round sticks and wood-encased pencils.

You can combine the rich, dark values of Conté with other mediums too. When used with oil or water, Conté dissolves into the surface, and it becomes permanent when dry. Using Conté over watercolor or acrylic adds visual texture and depth.

Carbon

Carbon is made from a mixture of the organic-based greasy soot of nonchemical elements such as wood or plants and other additives. Then the mixture is heat processed and encased in wood or paper. Carbon is not easily erased. Carbon pencils are graded H (hard), F (medium), and BB (softest). Carbon, like charcoal, is a rich, black medium, but carbon doesn't crumble or chalk off in the same way that charcoal does. Its firmer texture adheres to the paper and provides a sharper edge to the stroke.

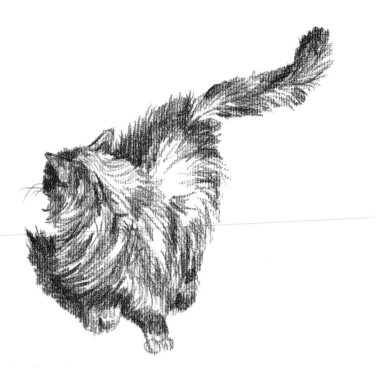

Try Conté crayon for rich tonal qualities without the mess of charcoal

While Conté does smear, it doesn't create nearly the mess that charcoal does. The intense black provides for simple, quick sketches as well as more-finished renderings. All drawing techniques, most blending tools and erasers will work with Conté as well. Try using it on charcoal paper, as I did here, to get the instant texture and layering possibilities.

Use the same sharpening tools for your new drawing instruments

You can sharpen charcoal, carbon and Conté in wood-encased pencils with a regular pencil sharpener. Use a sanding pad to change the tip into a wedge or chisel shape to create a wider, smoother stroke.

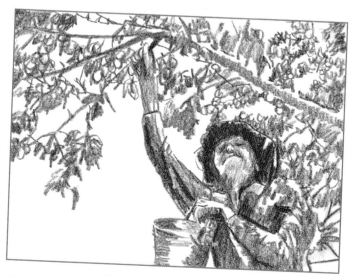

Try sketching with carbon

The soft 3B carbon pencil gives little drag and a smooth application, especially on smooth card stock. Carbon is a great medium for sketches, but keep in mind that it's nearly impossible to erase.

Technical Pens and Disposable Drawing Pens

Drawing pens come in a wide variety of quills, fountain pens, standard penholders with interchangeable nibs, and technical pens. My favorites are technical pens for their versatility, and disposable drawing pens for their convenience.

Technical pens produce consistent line widths specific to the size of the *nib* (pen point), which can range from .01mm to 2mm. Ink—black or colored—is stored in the pen barrel and feeds through the nib from a refillable reservoir or disposable cartridge. Standard penholders have simple plastic or wood handles and a variety of interchangeable nibs.

Disposable drawing pens are inexpensive and easy to use. There's no mess from refilling and the pigmented ink dries quickly and doesn't feather or bleed as you make strokes. The tips remain clog-free no matter what stroke or style you use. You can use them with templates and rulers, and they come with many different tip sizes. Practice strokes by placing, drawing and lifting the pen so you don't create blotches.

Choose archival, lightfast, permanent (waterproof and smudge-proof) ink with good adhesion. Pen type and drawing technique determines the paper you'll need. Ask your local art supplier for specific recommendations.

Begin pen renderings with a pencil drawing

I created a contour drawing in pencil that was shaded slightly before I began applying ink to it. Once the ink was dry, I erased any remnants of the pencil. Technical pens are an ideal medium to use for pointillism. I used four different nib sizes to create this drawing.

Remember, ink is not erasable. Use it for studies and sketches where erasing isn't an issue, or keep a stock of correction fluid in different shades of white to match different papers.

Ink for technical and disposable pens

No matter what type of pens you prefer, make sure you use only waterproof, light-fast, or acid-free, pH-neutral and pigmented ink.

Get disposable drawing pens in a variety of tip sizes

Disposable drawing pens are relatively inexpensive, so get several in your favorite tip sizes. Remember that once they're empty, they can't be refilled. I created this carnation using pens with superfine, fine and medium tips and India ink. Again, I started with a blind contour drawing with dimensional lines and values added.

Felt-Tip Pens and Markers

Felt-tip pens and markers are divided into two groups determined by their pigment carrier: water or alcohol. You can find them with pointed, chiseled or brushlike tips and in a range of widths from fine to broad. They are great to use for quick sketches or value studies.

Neutral colors of pens and markers are graded from light to dark in six or more values. The variety of tips available makes establishing shapes and refining drawings easy.

When choosing inks or felt-tip pens, look for the terms *archival*, *permanent* and *lightfast* to ensure you get ink that will not fade or smear.

Sketch with felt-tip pens and markers

Felt-tip pens and markers make great sketchbook tools. Use them to capture poses and rough values. Deliberate strokes made without hesitation produce clean, interesting shapes such as the ones shown here.

Always begin with contour drawings and studies

Just as you did throughout these exercises, begin your marker and felt-tip pen drawings with extensive planning and study stages. Simplify and analyze the shapes, relationships and value patterns in a subject.

Experiment with various tips and markers as well. A single stroke provides a transparent film on the paper. A second stroke adds more color and darkens the values. This rendering contains no black at all. I used white, medium-light, medium, medium-dark and dark pens.

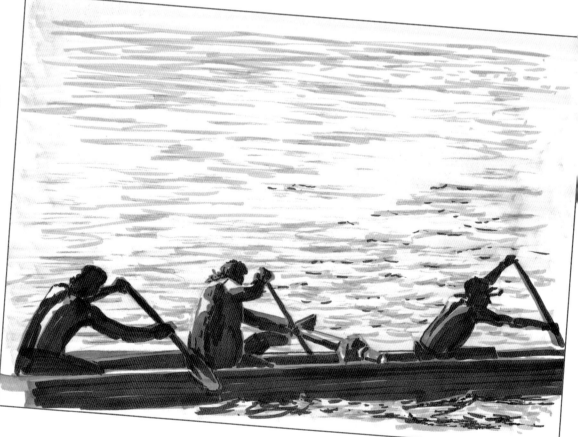

Dusting Powders and Brushes

Use dusting powders to collect loose graphite from a drawing. Just sprinkle the powder over the drawing and lightly brush it off with a soft-bristle brush. Dry cleaning pads made from powdered gum erasers and encased in a soft mesh bag also allow graphite dust to be brushed from a drawing without doing abrasive damage. A large, soft, natural-hair makeup brush will do the job, too.

Fixatives

Fixative spray stabilizes mediums. Use it either between layers while working or to protect the final rendering. Different types of fixatives meet artistic requirements for different mediums. Some fixatives allow erasing; others do not. Fixative finishes vary in character and include nonyellowing, clear, matte and glossy. Some fixatives can remove the glossy appearance of mediums.

Check a fixative's specifications and recommended methods of application before you purchase it. Note product warnings and instructions and reread before use.

Use fixative to protect your work

A fixative will keep your work from smearing or smudging. You can use it on your finished work, or between layers on drawings in progress.

Keep your drawing clean

It's important to keep a drawing clean as you work on it. Excess medium on your paper can smear and ruin a drawing. Look for dusting powders, dry cleaning pads and soft bristle brushes at your local art supplier.

GLOSSARY

Acid-free paper Paper with neutral pH and balanced acidity and alkalinity.

Archival The quality of materials that will maintain the pristine condition of your artwork over a long period.

Balance A compositional characteristic created as elements are arranged to form a well-proportioned whole.

Blind contour drawing A line drawing rendered by keeping one's eyes on the subject, not on the paper. The technique is used to develop an artist's observation skills and understanding of a subject.

Contour The outer line or silhouette of an image, form or subject.

Contrast The degree of gradation between values. Contrast can enhance or moderate the projection of objects in a drawing and aid in identifying planes within a composition.

Counterpoint A secondary composition element used to bring interest, support, and balance to the focal point and theme.

Critique A constructive assessment of both good and bad qualities of a creative work to aid an artist in growing to full potential.

Crop Cut down a work of art to make a stronger composition or eliminate unwanted parts.

Crosshatching A drawing technique that creates value with the repetition of intersecting lines.

Design The structure of a composition.

Focal point The center of interest in a composition.

Foreshortening A drawing technique that establishes the illusion of depth by making lines in projecting or receding objects shorter than they actually are.

Gesture drawing A technique of drawing done quickly to capture and communicate movement, expression or emotional reaction.

Harmony A pleasing effect created as the elements of a composition function in relationship to one another.

Highlights Effects created by light, re-produced by the artist with white and light values.

Image memory The ability of the mind to conjure up an image without the physical presence of the object. The faculty of the mind to remember the shape of an object.

Graphite on textured paper
Try graphite on extremely textured paper like this for lots of highlights. And always make sure your drawing surface is acid-free. Otherwise, your work may fade or discolor over time.

Lightfastness The potential of mediums to remain unchanged by exposure to light.

Negative space The area around positive "named" space, or the subject in a composition.

Permanent The quality of durability, waterproofness and lightfastness of mediums.

Perspective The illusion of depth and distance between planes in a drawing or painting.

Pointillism A drawing technique in which dots are used to create values.

Positive space The "named" space identifying the subject area of a composition.

Rhythm Consistent repetition in a shading movement.

Sizing A gelatinous mixture both added to the paper for substance and body and applied to the paper's surface.

Stump A compressed-paper stick pointed on both ends, used to blend, soften and tone pencil, charcoal, Conté crayon and pastel drawings.

Thumbnail sketch A small drawing study to quickly test compositions, shapes and value possibilities.

Tooth The degree of texture of a drawing or painting surface. Categories include smooth, medium and rough.

Tortillion Inexpensive, soft, heavy paper rolled to a point on one end to blend, soften and tone mediums. Used with charcoal, Conté and pastel.

Unity A quality created by the arrangement of elements in a composition to produce an aesthetically satisfying and pleasing whole.

Value The degree of lightness or darkness of mediums on a scale graded from white to black.

Weight A paper's thickness or density. Papers are labeled as light, medium or heavy, or in pounds per ream (grams per square meter). The higher the number, the heavier the paper.

Practice all the techniuqes

If you practice all the techniques, you'll be free to choose the one that best fits each subject and mood. The crosshatched lines captured the movement of this sea turtle beautifully.

INDEX

THE BEST ART INSTRUCTION BOOKS
COME FROM NORTH LIGHT BOOKS!

An ultimate reference book for artists. Popular artist Lee Hammond shows you how to make your work more lifelike and realistic with concise step-by-step instructions and basic techniques. Lee's book covers all subject matter and details how to draw still life objects, landscapes, plant life, water and skies, as well as transparent glass, metallic surfaces, bricks and fabric.

ISBN 1-58180-587-X, PAPERBACK, 160 PAGES, #33058-K

A complete course in drawing, this book by Barbara Bradley focuses on the clothed person as opposed to the nude figure. You'll learn proportion, perspective and value; how to draw folds and drapery; and all the tips you need to draw realistic-looking people.

ISBN 1-58180-359-1, HARDCOVER, 176 PAGES, #32327-K

Whether you're a beginning or more advanced artist, this guide will help you master the fundamentals of drawing and improve your artistic skills.

ISBN 1-58180-584-5, PAPERBACK, 216 PAGES, #33045

Follow author David Rankin's examples and exercises to learn dozens of quick-sketching methods for capturing depth, proportion and value.

ISBN 1-58180-005-3, PAPERBACK, 144 PAGES, #31500-K